M

Published on the occasion of an exhibition at the Hood Museum of Art,

Dartmouth College, Hanover, New Hampshire May 2-July 19, 1987

Patterns of Life, Patterns of Art

The Rahr Collection of Native American Art

With an Essay by Barbara A. Hail and Catalogue by Gregory C. Schwarz

Distributed by University Press of New England

Hanover and London, 1987

University Press of New England
Brandeis University
Brown University
Clark University
University of Connecticut
Dartmouth College
University of New Hampshire
University of Rhode Island
Tufts University
University of Vermont

The exhibition and catalogue have been made possible by the
Ray Winfield Smith 1918 Fund, by the Harrington Gallery
Fund, and by a grant from the National Endowment for the
Arts, a Federal Agency.

© 1987 by Trustees of Dartmouth College

Printed in the United States of America and Japan

LIBRARY OF CONGRESS CATALOGING-IN-PUBLICATION DATA
Schwarz, Gregory C.
 Patterns of life, patterns of art.
 "Published on the occasion of an exhibition at the
Hood Museum of Art, Dartmouth College, Hanover, New
Hampshire, May 2–July 19, 1987."
 1. Indians of North America—Art—Catalogs.
2. Rahr, Guido Reinhardt, b. 1902– —Art
collections—Catalogs. 3. Hood Museum of Art—
Catalogs. I. Hail, Barbara A. II. Hood Museum
of Art. III. Title.
E98.A7S39 1987 709'.01'1097307401423 86–34000
ISBN 0–87451–413–4
ISBN 0–87451–414–2 (pbk.)

Contents

Dedicated to the memory of Guido R. Rahr, Sr.

Jacquelynn Baas

Preface

In the fall of 1985, Mrs. Guido R. Rahr, Sr., carried out her late husband's wish by donating their collection of Native American artifacts to the Hood Museum of Art at Dartmouth College. The Rahr Collection includes a wide variety of objects manufactured in the native cultures of several regions, although most of the items are from Plains and Northern Woodlands peoples of the late nineteenth and early twentieth century. This generous gift significantly enhances the quality of our Native American collection, while expanding the range of Dartmouth's teaching resources for the study of material culture on this continent. The exhibition provides both an opportunity to express our deep gratitude to Mr. and Mrs. Rahr, and public recognition for the collection judiciously gathered by Guido R. Rahr, Sr., over a considerable period of time.

Guido Reinhardt Rahr was born on March 25, 1902, in Manitowoc, Wisconsin, where his family owned a large malting company. After graduating from Yale University in 1925, Mr. Rahr joined the family business, later becoming chairman of the board and chief executive officer. Mr. Rahr was active in civic affairs, and his generosity contributed to the success of many local and state projects. He was especially concerned with conservation issues, serving for twenty-three years as a member of the Wisconsin Conservation Commission. He received numerous awards for this work, including, in 1966, being named Conservationist of the Year by the National Wildlife Federation.

But Mr. Rahr's interests were not confined to nature. His fine collection of Native American art and artifacts is testimony to his appreciation of the culture of this continent. Perhaps sparked by memories of childhood summers spent in a lake-side house in northern Michigan, at a time when local Native Americans still used birch bark canoes to harvest wild rice, Guido Rahr's interest in native cultures continued throughout his life.

Thanks to the detailed and richly informative overview provided by Barbara Hail, Executive Director of the Haffenreffer Museum of Anthropology, Brown University, the objects in the Rahr Collection can be appreciated from the perspective of their social and cultural contexts, which she describes with particular sensitivity to the role of historical change. The delight in beautifying functional objects of all kinds is one of the major revelations of a traditional Native American collection, particularly one as wide ranging as this. We are indeed fortunate to have Ms. Hail's indispensable guidance in this project, especially since, as she explains in her concluding section, the precise origins and purposes of manufacture are unknown for many of these pieces.

Hood assistant curator Gregory Schwarz has been diligent in researching and cataloguing the Rahr Collection, and the results of his work appear in the second half of this publication. Senior curator Tamara Northern has administered the project with her usual good judgment and perseverance, providing its organization and supervision. Holly Glick, Director of External Affairs for the Hood, worked with Ms. Northern to secure funding for the exhibition from the National Endowment for the Arts. Grateful mention should also be made in this context of Gregory S. Prince, Jr., Associate Dean for Academic Planning and Resource Development, who helped to make this project possible in many ways.

Ms. Northern, Ms. Hail, and Mr. Schwarz have asked me to thank the following people for their

generous assistance: Richard Conn, Kate Duncan, William Fitzhugh, Richard I. Ford, George P. Horse Capture, Mark Humpal, Meredith Kendall, William W. Newcomb, Deborah L. Nichols, Albert H. Schroeder, and A. H. Whiteford. In addition, I would like to express our thanks to members of the Hood Museum staff who played important roles in the creation of this exhibition and catalogue: Hood curator for museum education Mary Sue Glosser; preparators Evelyn S. Marcus and Robert M. Raiselis; curator for exhibitions Malcolm H. Cochran; and administrative office staff members Theresa M. Delemarre, Hilary L. Ragle, and Joanne M. Sugarman.

Finally, I would like to thank those whose generosity has truly made this exhibition possible.

The late Ray Winfield Smith, Dartmouth class of 1918, and his family, created the endowment fund that has supported this exhibition, catalogue, and accompanying symposium. This assistance has been supplemented by that of the Harrington Gallery Fund and the National Endowment for the Arts, whose enlightened policy of providing matching funds for the utilization of museum collections makes objects that are part of our national patrimony available to the general public as well as to the scholarly community. In the case of the beautiful objects in the Rahr Collection, such sharing is cause for celebration indeed.

JACQUELYNN BAAS
Director, Hood Museum of Art

Barbara A. Hail

Traditional Native American Art of the Plains and Northern Woodlands

Since prehistoric times, the aesthetic systems of Native American art forms have been a continuing and successful expression of self-affirmation, social identity, and the endurance of Native American cultures. Traditional art expresses the deepest ideals of a people's way of life. The art represented by the objects in the Rahr collection was firmly rooted in the society of the native people living in the northern woodlands, mid-western prairies, and western plains of North America during the nineteenth and early twentieth centuries.

Since the advent of Europeans on the American continent, a variety of influences have caused changes in the lives of the native inhabitants. As European settlement increased along the Eastern coast, native populations were pushed westward, encroaching on the territory of people who already occupied the area, which resulted in conflict and in further disruption of native groups. The appearance of European trade goods was another factor that created changes in local methods of manufacture, subsistence, and decoration, long before the actual arrival of significant numbers of Europeans in the midwestern and western areas of the continent.

For thousands of years the presence of bison herds on the Great Plains, in seemingly endless numbers, provided subsistence for native people. They knew how to use the products of this mighty animal: the sinews for cordage; the hides for lodges, robes, footgear, and containers; the bones for tools; the meat for food; and the chips for fuel. Because of the difficulty of following the bison on foot for long distances in the arid environment, most groups of native people lived on

the edges of the Plains where there were adequate water, grass, and trees, making only occasional hunting forays into the interior. The first European intrusion came in 1541, when a mounted party of Spanish explorers under the leadership of Coronado rode northward from Spanish-held lands in present-day Mexico. The most important legacy of their journey was the introduction of horses to the Plains, providing the necessary mobility for occupation of the area by native people. Within two hundred years, horses were widely dispersed northward and eastward from the Spanish breeding farms near Santa Fe. They were distributed through a lively trade network in which both the Spanish and Native Americans participated. Guns, traded through the Mandan and Hidatsa villages on the northeastern edge of the Plains, close to the center of the fur trade, were exchanged for horses, which were driven up from the southwest, changing hands in trading centers among the Navajo, Ute, Nez Perce, Crow, Mandan, and Hidatsa.

By the eighteenth and nineteenth centuries, a successful semi-nomadic culture existed on the high Plains, dependent on the horse and the bison. Within roughly defined tribal territories, camps moved seasonally, following the migration of the bison. Camps were loosely organized into bands based on male societies with chiefs selected on the basis of their capacity for leadership. Intermittent raiding among tribes, spurred by rivalry for hunting grounds and for possession of horses, helped to create a system of war honors based on individual bravery. Warrior societies extolled feats of personal courage. The survival of the band was

dependent on strong guardianship of the camp by its warriors. Male prestige, vital to success in this warrior society, was heightened by leadership of successful raids, especially those resulting in the acquisition of horses and other portable evidences of wealth.

A man's success in war and the hunt depended on successful visionary experiences. Historic Plains groups had a spiritual identification with the natural forces around them. Communication with these forces was achieved through fasting, solitary vigils, self-torture, and the smoking of ceremonial tobacco. Spirit helpers, usually animals who appeared to them in their visions, brought messages of conduct that men sought to follow in their lives. Women also sought the aid of certain spirit helpers who were understood to provide protection during childbirth and in the nurture of children.

The nomadic character of historic Plains life made portability a necessity. Clothing, horse trappings, shelter, and household goods had to be carried with the band and thus became the logical objects for decoration. Ornamentation of these objects created prestige, both for the maker of the objects and for the owner or wearer. Lodge covers, shirts, and weapons bore decorative markings that might indicate membership in a society, the war honors of the owner, or leadership roles, and in general signified the owner's status in the community.

The most available natural resource on the Plains was animal hide from bison, elk, deer, and antelope. Plains people became highly skilled in working with hide. They used it in the form of rawhide for moccasin soles, bindings, horsegear, and envelope-shaped containers (parfleches) that held dried meat and clothing. They meticulously softened it through tanning to make shirts, dresses and leggings, lodge covers, storage bags, quivers, and later gun cases. They decorated the hides with porcupine quills, paints, and shells, and, after European trade goods arrived, with glass beads and metal tinklers. Further west in the Plateau area a unique type of flat, utilitarian bag was contrived using native hemp and cornhusk, with the addition of dyed trade wool in the later nineteenth century (Cat. 64). Native artists imaginatively combined natural materials from the local environment and manufactured trade goods to produce their material culture and art.

The fur trade brought French and English trappers and traders into the Northern Woodlands areas in the seventeenth century and into the Plains somewhat later. In return for the furs of beaver and other animals the Indians obtained guns, glass beads, woollen cloth, silk ribbon, metal knives, axes and kettles, tobacco, and alcohol, among other things. Through their early exposure to and involvement in the fur trade and the often accompanying Christian proselytizing, the native peoples of these areas developed patterns of living and ideas of design that reflected much acculturation. Hunting, trapping, and the seasonal round of rice harvesting and maple sugaring were carried on as before, but the market for many Indian products was defined by the fur trade. Interest in European trade goods was keen among both men and women. Certain articles of European clothing and decorative design were adopted and modified to suit native ideas of design. The late-nineteenth and early-twentieth century Great Lakes styles of flamboyant, floral bead embroidery on bandolier bags (Cat. 108, 111) and articles of clothing (Cat. 129), and of bead-woven garters and sashes, reflect an adaptation of European style. Still, in keeping with a culturally rooted native art, these woodlands peoples continued to use the natural materials around them to create useful and beautiful objects. The abundant wood of the area was shaped into graceful spoons and bowls and into board cradles (Cat. 70). Like their Plains cousins, women of the Great Lakes used porcupine quills in elaborate ways as an embroidery device on hide and as a decorative wrapping.

The Nature of Traditional Art

Traditional art is embedded in culture. The form objects take is influenced by the life-style of the people, available materials, the purposes for which the object was conceived, and the aesthetic values of the creator and of the society. In the creation of objects the triad of sacredness, beauty, and harmony or appropriateness to intended use was important to all Native American people (Conn, pers. com. 1985). In traditional Native American society there was little concept of "art" as an ideal apart from society, as it has grown to exist in the Western world. Rather, objects were shaped and decorated with great care because they already had a firm place in the community consciousness. Some were important to sacred ritual (Cat. 71, 72); some were gear necessary for transportation,

the hunt, war, storing or carrying goods (Cat. 61, 67), as clothing (Cat. 136), or for child care (Cat. 68–70). Other objects were important to denote prestige, acting as a visual sign of one's place in society. Highly decorative headwear (Cat. 182) and shirts (Cat. 134) signalled the respect due to a leader who had proven his devotion to his people by winning war honors. Ceremonial staffs (Cat. 50), dance shields, and other regalia indicated membership in particular societies originally formed to ensure success in the hunt, protection for the camp, and an orderly governing of the tribal body. Pipes and pipe bags, adjuncts to the prayerful smoking that was an important part of a man's personal religious orientation, were usually decorated with personal symbols of his successes in war (Cat. 90, 99). Other objects were made as gifts to loved ones, especially children (Cat. 137, 174). The most highly prized objects were given away as a means of honoring others and as an expression of the virtue of generosity. Other objects, especially highly decorated clothing, were a response to the desire to "dress up" and to the traditional feeling that decorated dress was an important element of prestige (Cat. 128, 129, 132, 133).

Both men and women created. Men usually excelled in carving, in both wood and stone, and in feather work. Women were expert in the cutting and sewing of animal hides for clothing and shelter, and in embroidering hides and later wool cloth with porcupine quills, shells, and glass trade beads. Painting was practiced by both men and women. On the Plains, men's painted art was traditionally figurative, telling stories of tribal history or personal exploits, while women's painting was abstract, a beautification with geometric designs of rawhide containers and of the bison robes that, in earlier times, before the demise of the bison, were the winter wrap of both men and women.

Traditional art is by nature conservative and slow to change. It functions as a symbol of continuity, as a reminder of past ways of thinking and doing. If an object made for a ritual function has been successful in the past, there is no reason for changing its design. In fact, to do so might affect its power. In nineteenth-century Plains culture, bison horn headdresses were worn in dances to "call in" the bison in preparation for a hunt. If a hunt was successful, the form of headdress used in that dance became accepted as powerful and its

design was considered a part of its power. When new headdresses were made they were likely to follow closely the design of older successful ones. For functional reasons, then, innovation was not encouraged as much as continuity in traditional art.

However, since the conception for the design and materials of ritual objects in nineteenth century Plains culture was usually vision inspired, the individual dream or vision of the warrior or hunter determined the make-up of the object. Variations in the details—decisions about which animals or parts of animals would be included, which colors of mineral or vegetable paints to use, and which designs to draw or carve—depended on the instructions given by the spirit helpers to an individual in his vision. These instructions were unique to each vision. In this way, individuality of expression could exist within a traditional art framework. This is well exemplified by the painted tipi designs of the Kiowa and Blackfoot. Each design was dreamed, and executed on the lodge by the dreamer himself and by his friends. The designs were passed down in families or transferred with appropriate ritual to others, resulting in great individuality of expression in this form of art.

Changes come to traditional art when new materials, such as European trade goods, become available, or when old materials are no longer available, as happened when the great bison herds of the Plains were reduced almost to extinction in the 1880s. Changes also occur when forces outside the society disrupt its internal structure. This happened to Native American groups of the Plains, Great Lakes, and Intermontane areas in the latter part of the nineteenth century, when, defeated in war, they were placed on reservations.

The Transition to Reservation Life, 1870s to 1940s

Reservation life brought an end to freedom and mobility. This period, which began in the 1870s, was one of transition for the native communities whose mode of subsistence had traditionally been independent hunting, gathering, or semi-agricultural. Following their defeat in a series of battles with the United States Army for possession of the Western territory, they found themselves in a condition of containment on government-designated "reservations." They were forced

to accommodate to the standards of an incomprehensible society, one of great size and wealth, obsessed with the competitive manufacture and exchange of material goods, and committed to the missionizing of the native peoples of America. The assault on native culture was deliberate. The United States government was convinced that the solution to the Indian question was to assimilate them as Christians, farmers, and small businessmen into mainstream America.

To accomplish the reeducation of an entire people, the federal government established boarding schools to which native families were strongly encouraged to send their children. At school the students were taught only in English. Their hair was cut upon arrival and their clothes exchanged for western-style school dress. They were taught agriculture and home economics. Little attention or praise was allotted to previous native learning, either in subsistence skills or in the arts, and much energy was put into discrediting traditional spiritual beliefs that contradicted those of Christianity. Ethical and moral standards consistent with the old beliefs were seldom given serious consideration. Upon leaving school, young people found themselves caught between the opposing values of their parents and of their teachers. A typical product of this education system was James Murie, a Pawnee ethnographer, who wrote in 1893, as a student at Hampton Institute, "I want them [the Pawnee] to put their superstitious ideas aside, and believe in the white man's Great Spirit" (Murie 1981, 22).

Most young people returned to their families after schooling and tried to make their newly learned farming skills work on the generally poor reservation acreage. Farm equipment was inadequate and domestic farm animals too expensive to purchase. It was a time of poverty and despair. Both economically and spiritually the Native American way of life had been questioned. Previously recognized roles for men and women no longer existed, yet the roles urged by mainstream American society did not seem palatable or achievable for most. In the words of Smohalla, chief of the Wanapum tribe of the Plateau in 1884: "My young men shall never work. Men who work can not dream, and wisdom comes to us in dreams . . . You ask me to plough the ground. Shall I take a knife and tear my mother's bosom? You ask me to dig for stone. Shall I dig under her skin for her bones? You ask me to cut grass and make hay and

sell it and be rich like white men. But how dare I cut off my mother's hair?" (Mooney 1896, 716).

In the face of these intense pressures upon the cohesiveness of Native American society it is wonderful to record that the quality of artistically decorated objects produced during this transitional period remained exceptionally high and that the quantity increased. With more leisure time than they had been used to in the past, women took advantage of the availability of new materials such as inexpensive glass seed beads and woollen cloth, combining them with long-used natural materials such as porcupine quills and animal hide to create a large number of decorated objects that related in important functional and spiritually protective ways to their lives. The men continued to produce certain ritual objects that reinforced their traditional spiritual beliefs, and to record in figurative drawings the major historical events of their past. The legacy of this creative outpouring successfully communicated the unique individual and social identity of the artists to their own people, to the dominant white society of the time, and to the future. Undoubtedly, the process of creation and the knowledge that they were passing on to younger generations their traditional cultural ideals through their art became a source of strength that sustained the artists during this most difficult half-century.

Because of the sedentary nature of reservation life, changes occurred in the material culture of the people. With the disappearance of the bison herds in the 1880s, the staple source of food and raw materials for production vanished. Objects related to nomadic mobility were no longer needed, since the stationary log cabin had replaced the portable hide tipi. But even though mobility had ceased, the decoration of clothing and of household goods continued to be important as a carryover of earlier ways of thinking about objects suitable for care and ornamentation. These objects still related primarily to ritual, utility, prestige or place in society, and love of family. In addition there was a growing trend toward making objects for sale to an outside market.

New objects relating strictly to reservation life were decorated; old flint and steel ("strike-a-light") bags were now used as cases for ration tickets (Cat. 79) for the government meat ration; old tipi disc ornaments became new rounded purses to hold coins and bills, a newly acquired commodity. Vests cut in western style but fash-

ioned of hide from deer, elk, and cow, were fully beaded in glass seed beads or embroidered with porcupine quills, which were now dyed with commercial, rather than natural vegetable dyes (Cat. 126, 131). They were worn by both men and boys on dress occasions, and were also commissioned by non-Indians, especially army officers stationed on posts near reservations. New forms of religion, such as the peyote ceremony of the Native American church, resulted in the production of silver jewelry and beaded prayer fans (Cat. 11). Christianized Indians found pleasure in decorating bibles and ministers' vestments with beads.

Many of the traditional objects continued to be made. Clothing, formerly sparingly quilled, pony-beaded, or painted on animal hide, was now more elaborately decorated with glass seed beads, often in lazy stitch (on the Central Plains), which allowed a large area to be covered in a not-too-arduous time frame. Dress bodices, male shirt strips, blanket strips, and commercial leather-panel belts were ornamented with beads. Gun cases were beaded at either end (Cat. 102–5); pipe bags were beaded, painted, quilled, and fringed; metal tomahawks were beaded and often given as gifts (Cat. 20). Footwear continued to be traditional even when most other hide clothing had been replaced with cotton and wool. Hide moccasins with beaded or quilled decoration (Cat. 155, 170) remained popular among native people because of their comfort and practicality, becoming a common sale item to non-Indians as well.

The changes that resulted from transition occurred over an extended period, as those who had grown up in the days before reservations lived out their lives and finally died. As long as old people remembered the past the traditional forms and ideas were alive and meaningful. The "lost generation" who was brought up in the early years of the twentieth century was the greatest victim of change. They did not receive complete indoctrination into the old beliefs nor were they routinely taught technical skills in the arts. But by the middle of the twentieth century, the interest of both non-Native Americans and Native Americans in the old ways of thinking and in the old arts had been rekindled, and many former craft skills were being relearned by young people. Today in the 1980s, a strong revitalization of Indian arts is in process. The honored skills of porcupine-quill embroidery on hide, glass seed bead embroidery on hide and cloth, hide painting, stone

and wood carving, feather work, silver work, pottery, and ornamental shell and stone jewelry have been revived and have become important both as sources of economic success and of pride in culture (Coe 1986). New areas have been explored as contemporary native artists compete successfully in the larger world of art.

Continuance and Innovation

We might expect that many objects from the pre-reservation period would disappear from manufacture and that new objects would appear. This did happen, yet native artists were surprisingly tenacious in continuing to make many things that had formerly been of importance. Among these were storage bags, pipe bags, drums, roaches (a kind of headdress), eagle-feather headdresses, baby cradles, and the parfleche, which Native Americans resumed making long after their function as portable packing cases had ceased to exist. Fancy dress clothing for both men and women, constructed of the traditional materials of hide, cowrie shells, elk's teeth, ermine, porcupine quills, and the important trade item, glass seed beads also still continued to be produced by Native Americans.

Anthropologists have explained the tendency of a people to revive archaic traditions during a time of stress and change as a means of bolstering a sense of identity based on the past. These revivals have been called "archaisms" (Dawson, 1974, 52). In addition to revivals of material culture there are revivals of social institutions such as feasting and dancing, which, in the case of Native American groups, took place at group get-togethers known as pow-wows. Among Plains groups these get-togethers may have recalled earlier nomadic times, when bands that had been separated in order to ensure survival during the winter came together in the spring for the communal bison hunt. These were a time of reunion for families, of reorganization of tribal leadership, and of ceremonies in honor of the great spiritual force of the sun, through which the earth and all its creatures had once again been renewed.

The pow-wow circuit, which remains a strong revitalizing force in the 1980s, is responsible for diffusion and change in the design and creation of material culture, through its ability to attract a great mixture of peoples. At the same time there has developed a growing conformity of output

and a change in the meaning of some objects. Certain articles such as the roach, formerly related to ritual and prestige, have now become a regular part of men's dance costumes. Ribbon shirts have become pan-Indian wear. Since the late nineteenth century, when Buffalo Bill's Wild West Shows toured the world, the swept-back eagle feather headdress has become the recognizable symbol, not of the war honors of a high Plains chief, but of all Native Americans. Individuality of bead designs and technique of application, which formerly made it possible to distinguish among the work of different peoples, had largely disappeared by the third quarter of the twentieth century. A second revitalization of native art has been operating during the past ten years, and certain revivals of nineteenth century localized designs have reappeared. Thus, pride in being identified as part of a particular group once again seems to be important to native artists.

The Economic Impact of Changed Life-Styles

During reservation days it became necessary for most native peoples to supplement their incomes. Many cherished traditional objects were sold to the outside world at this time. Some people, recognizing the interest of non-natives in their traditional arts, took the opportunity to obtain needed cash income by creating new handwork, made especially for sale. In some cases government or church-sponsored cooperatives aided the craftsperson to purchase materials at group rates for reduced fees, and provided instruction for novices, a regular place to work, and a market for finished articles. Such a church-sponsored cooperative operated successfully at Oglala, South Dakota, on the Pine Ridge Reservation in the 1930s (Thorburn, pers. com. 1986). In Browning, Montana, on the Blackfoot Reservation, a cooperative was organized in 1936 under the sponsorship of the Indian Arts and Crafts Board and the Education Division of the U. S. Indian Bureau. According to John Ewers (1945, 63), then curator of the Museum of the Northern Plains in Browning, this cooperative revolutionized Blackfoot handcrafts, raised quality by controlling standards, and provided a solid source of income for craftspeople.

It is interesting to note the modifications that we made in the type of object decorated and in the type of decoration applied on those objects that were made specifically for outside buyers, as compared to earlier objects made for use within the tribe or for trade. Variations in size, materials, amount of decoration, form, and function occurred (Dawson, 1974, 24). Stone-headed clubs and decorative staffs were made smaller so that they would be more easily portable for the tourist purchaser. With light-weight shafts and weak attachments, they were obviously no longer functional (Cat. 31). Models of large objects such as cradle boards, tipis, and canoes were popular. Smaller baskets and ceramics were produced in the southwest about the turn of the century as well as true miniatures; a revival of miniaturization has occurred in the 1980s. Miniatures, however, are also a means of exhibiting the skills of craftspersons to their own people, and therefore they serve one of the traditional functions of art by bringing prestige to the artists.

With commercialization there came a tendency to produce objects more quickly, and in the easiest possible way. Bead decorations on moccasins became sparser and more repetitive in design. Hides were tanned commercially rather than in the native way, which had involved using the organs of the animal and much physical twisting and wringing. One Cree beadworker explained that most purchasers did not appreciate the time and work involved in the more complicated traditional processes and were not willing to pay for it. She said that most artists saved their best pieces, made in the old manner, for use within their own society, as gifts and as pow-wow wear (Hail 1985).

Often the form of objects made for sale changed, with emphasis on ornamental jewelry, belts, bags, moccasins, barrettes, tie holders, and key chains, rather than on dresses, shirts, and leggings. Because of the desire of white patrons to purchase exotic materials, re-creations of ritual and status objects such as feather headdresses were made. The objects still had a function, albeit an economic one designed to provide a living for the maker rather than one based on form.

Sacred Art and the Extent of Symbolism

It is well documented that the designs found on Plains and Woodland ritual material such as medicine bundles, Midewiwin Society bags, shields, tipis, and some war shirts, as well as in

body paint, were vision inspired. A youth who had received a vision would be instructed to make up a bundle representing the animal spirit helper who had come to him. A mature warrior might be instructed in the materials and cut as well as the design for a headdress, shirt, or shield. Painted designs executed by men were usually quite realistic representations of animal spirit helpers or of the messages they had conveyed. Although ritual material was highly symbolic, it was a personalized symbolism, reflecting the individualized nature of the visionary experience.

When a man wished to have his war honors represented in quill or beadwork, he asked a woman to execute the designs. Until the end of the nineteenth century these designs were most often accomplished in the form of geometric symbols, and certain of them were well used and widely recognized. Among these were the feather, which represented the eagle feather given to a warrior who had performed a brave deed or "coup" (Cat. 89, 99, 137); the whirlwind, representing confusion or dust blown into the eyes of the enemy; and horses' tracks, representing the number of ponies captured from an enemy. Among the Cheyenne and Arapaho, a symbol of the culture hero "Morningstar" was frequently applied to male regalia in the form of a four-pointed star (Cat. 90). An early realistic symbol was the pipe, representing the "pipe carrier," or leader of a raiding expedition.

Women of both Plains and Woodlands groups also received information through visions. Mountain Wolf Woman, a Winnebago (Lurie 1966, 67) recorded in detail one of her visions, although she did not tell us whether any design or object was created as a result of it. Information from Lakota women in the early part of this century indicated clearly that women received ideas for quill designs from dreams, and that these designs were generally recognized as sacred or *wakan* (Wissler 1912, 79, 92–94). The initial idea of using porcupine quills in embroidery was considered to be a gift to a particular young woman through her dream from Double-Woman, a supernatural being important to the Oglala. Before this, no one had imagined the quills to be of any practical use (Wissler 1912). Following this dream inspiration, the sacred nature of quill embroidery became institutionalized among the Cheyenne, Lakota, and Arapaho people. Sacred quilling societies were formed that required initiation. They were open

only to women of excellent moral character. Certain articles of quillwork were expected to be completed as a woman earned the right to be a member of the society.

As increased acculturation put a strain on the transmittal of traditional learning, the geometric designs applied on objects by women for their own use seem to have become mostly decorative. Their meanings (if present) were personal rather than widely understood. The exceptions relate to protective motifs involving the nurture of children and the reproductive role of women. Protective designs were placed on the tops of Cheyenne, Lakota, and Arapaho cradles where they covered the infant's head, and on the square tab extension at the top rear of soft cradles (Cat. 68). A common motif was the spiderweb, which, since it was known to withstand bullets and arrows and even wind and rain without breaking, was therefore considered a powerful guardian for the child (Wissler 1907, 49). Geometric motifs were often arranged in groupings of four—a sacred number—and four-pointed stars or crosses representing the four directions of the world were often embroidered on clothing and cradles. Sometimes an entire cradle would be embroidered in a protective motif such as the thunderbird. An abstract design representative of the turtle, symbol of nurturing and childbearing, was commonly applied on the bodices of women's beaded dresses and on their leggings. Beaded, turtle-shaped amulets were made to contain the umbilical cord of a new infant. The tab of the soft cradle hood (Cat. 68) in the Rahr collection has a beaded motif that probably represents a turtle.

Storage bags used by women for clothing and personal gear were typically decorated with rows of parallel lines (Cat. 66, 67). These lines, also applied to women's bison robes in earlier times, represented the path of life for a woman, with special reference to her entrance into puberty. The lines, originally executed in red quillwork (Cat. 66), were a symbol of the period of a woman's life during which she could bear children. Women who decorated storage bags such as Catalogue number 66 with red quilled lines were considered in the highest grade of the Cheyenne sacred quillers' society (Powell 1976, 36).

Colors had ritual symbolism, sometimes depending on the context of their use by both men and women. Among Central Plains people, red, yellow, black, and white were the four most sa-

cred colors. All of these colors, which were obtainable from natural earth pigments, had been in use long before the advent of European trade colors. Arapaho quilled cradles and tipi discs were universally composed of these colors. Among the Cheyenne, according to a member of its priestly society, red represented the color of blood or the life force. Yellow was the sun, giver of life. Black was the color of victory, or of enemies killed. White, which represented light or morning, indicated a prayer for long life and for completing the sacred circle of life with its fulfillment in white-haired old age (Powell 1976, 34–35).

Ritual

Among both Plains and Woodlands people, beautifully decorated ritual materials were the result of vision or dream inspiration. Two excellent examples of ritual art from the sacred Midewiwin Society, which was important among Great Lakes groups, are included in the Rahr collection (Cat. 71, 72). When the ethnographer W. J. Hoffman (1891) carried out initial research on the Midewiwin Society for the Bureau of American Ethnology in 1885, he obtained heretofore secret ritual information from priests of the society. At that time the government was in the process of carrying out a treaty with the Ojibwa people by which they would relinquish their widely dispersed homelands in Minnesota and Wisconsin and move to the Red Lake and White Earth Reservations, ceding to the United States about four million acres of land. In return, they would become citizens, hold their lands in severalty, and come under the influence of government schools and missions to a much greater degree than they had when they were widely dispersed. The Mide priests realized that such a severe change, both in location and in traditional habits, would threaten the continuing strength of the Midewiwin ceremonies. Because they feared that the information passed down within the society might be lost, they were willing to share it with Hoffman in order that it might be preserved for the future knowledge of their descendants. In a similar situation, Pawnee priests shared ritual information with James Murie in order to save it for posterity (Murie 1981, 196).

At the time of the transfer of information, it was still customary for Ojibwa youth, like their counterparts on the Plains, to seek a visionary experience through fasting and solitary vigil. Animate or inanimate objects seen in these visions, dreams, or hallucinations, were adopted as personal guardian spirits or *manidos*. An effigy of this manido was made and carried about with the vision owner, either around the neck or in a medicine bag. The future course of one's life was considered to be determined by this dream. Sometimes a youth who had experienced a powerful fasting dream sought to become a member of the Midewiwin Society.

The Midewiwin, or Society of the Mide, were medicine men and women who were consulted in all times of sickness. They effected extraordinary cures, both by the application of roots and herbs and by incantations (Hoffman 1891, 162). The Mide priests preserved birchbark records bearing incised lines that represented in pictorial plan various kinds of ritual information of importance to initiates. These records were sacred and not exposed to public view. The origin of the Midewiwin, as contained in one of the birchbark records known as the Red Lake chart, was recorded by Hoffman (1891, 166). To summarize this record: Minabozho (great rabbit), the servant of Dzhe Manido (the guardian spirit of Midewiwin), descended to earth to give the Midewiwin to the Anizhinabeg (original people, human beings, ancestors of the Ojibwa and Ottawa, Potawatomi, and Menomini). He did this because the principle deity of the Ojibwa, Kitshi Manido, saw that the people had no means of protecting themselves against disease and death. Kitshi Manido sent Minabozho to give them the sacred gift of healing and to provide them with animals and plants to serve as food. Minabozho appeared over the waters, and looking for a means of communicating with the people, he heard something laugh and saw an otter swimming about. He instructed the otter in all the mysteries of the Midewiwin. The otter was given the sacred rattle to be used at the side of the sick, the sacred Mide drum to be used in initiation ceremonies and at sacred feasts, and tobacco to be used in making peace and in invocations. Minabozho built a sacred Mide lodge and sang a Mide song. He shot into the otter's body the sacred white shells, or migis, which were in his Mide bag, so that the otter might have immortality and be able to confer these secrets to his kinsmen, the Anishinabeg.

Fortunately for posterity, because the Midewiwin priests hoped to perpetuate the sacred knowl-

edge of their people's traditional beliefs, the ritual meaning of otter skin Midewiwin Society bags has been saved and documented. As a result the bags may be appreciated for their spiritual role in Great Lakes native society as well as for their inherent beauty.

Prestige

The large and colorfully beaded bandolier bags made as prestige items by late-nineteenth-century Great Lakes tribes had their origins in smaller bags of varied construction. Among these were two-panel, quill-woven bags, which were popular further northwest between Lake Superior and Lake Winnipeg; square, beaded bags with triangular flaps, which originated in the southeast; and finger-woven yarn bags with interwoven beads, which were made by the Huron and Iroquois of the eastern Great Lakes in the mid eighteenth century (Whiteford 1986, 39). Earlier bags were containers for travelling and hunting. Later bags were made as gifts of friendship, or were worn as prestige items in dress clothing, sometimes two at a time. As they moved out onto the Plains as gifts, they were often used as horse ornamentation and placed around the horse's neck to hang over the chest. As they became more truly decorative in function, the pouch was sometimes eliminated altogether and replaced with a beaded panel.

By 1870 beaded bandolier bags of the Great Lakes region had achieved a basic style of solid woven beadwork in diamonds and X motifs (Cat. 110), which they kept until the end of the century (Whiteford 1986, 42). The subdued colors of the woven beadwork were in keeping with the soft natural dyes used in their quill-woven antecedents. About 1890 exuberant floral designs became popular on the bags (Cat. 108). The designs were inspired by European patterns that reached this region through the fur trade and accompanying missionization. Instruction in embroidery techniques was commonly part of a young Indian girl's education in a mission school.

Bandolier bags were also worn by Ojibwa Mide priests as part of their dress regalia when participating in ceremonies of the Mide Society. In addition to decorated shirts, trousers, moccasins, garters, collars and head decorations, the priests wore bags made of cloth, beautifully ornamented or entirely covered with beads, supported at the side by means of a broad band passing over the opposite shoulder (Hoffman 1891, 298). The priests used the bags for holding personal paraphernalia during the ceremonies.

On the Plains, the warrior's shirt was often highly decorated, as a measure of his prestige. The shirt (Cat. 134) attributed as having belonged to Pretty Eagle, a Crow warrior who participated with Chief Plenty Coups in some of the Crow's last war raids during the latter part of the nineteenth century, is typical of the Transmontane style of geometric bead design common to Crow, Plateau, and some Basin peoples in the 1880s. A photograph of the Crow delegation to Washington in 1880 shows all of the prominant Crow leaders wearing similarly decorated beaded shirts (Wildschut and Ewers 1959, Fig. 3). It is decorated with ermine strips and seed beads in a variety of soft pastel shades of blue, violet, pink, green, and yellow. The ermine, or weasel, was known to be a fierce fighting animal. It was frequently attached as good war medicine to shirts, shields, and war clubs (Ewers 1977, 260).

Utility

The ideal of harmony, or appropriateness to intended use, is particularly noticeable when applied to utilitarian objects that have been decorated in order to make them beautiful. Such "beautification" better fulfilled the purpose of the object by adhering to the norms of Native American society, which valued objects of enhanced aesthetic quality. The painted rawhide container (Cat. 61), trunk, or box, serves the function of storage. It is lightweight, easily movable, practically indestructible, and pleasing to the eye. Variations of these painted rawhide containers folded in envelope shapes, which were called "parfleches," were common on the Plains in nomadic times, as they were easily carried on either side of a moving horse. A tubular shape was used for storing eagle-feather bonnets, and small trapezoidal shapes were used to hold ritual medicine bundles. In the nineteenth century the box shape was more typically used by sedentary Prairie groups. In the twentieth century they were also made by the women of Standing Rock, North Dakota.

Because many of these utilitarian containers had once served as buffalo-meat carriers, they came to have a special hold on the hearts of people after the bison had disappeared from the

Plains, as reminders of earlier, happier days. Although for a while people had begun cutting up the painted containers in order to re-use the rawhide for moccasin soles or small hand bags, there was a revival of interest in them around the turn of the century. They were recreated in their original designs and forms, but were usually made of cow or elk rather than bison hide. However, a limited supply of bison hide continues to be available from protected, tribally managed herds, and some rawhide containers are once again being made of bison.

The Family

The Native Americans' love for their children was a source of creative artistic inspiration that resulted in beautifully crafted cradles, toys, dolls, and clothing throughout the transition from pre-reservation to reservation times. Dolls with intricate and authentic clothing details (Cat. 174) were made by Plains women for their children's amusement. As in other areas of life, learning was combined with play. Through imitative learning while at play, small girls became familiar with the cut and design of their people's clothing, and thus began the process of learning how to create it themselves.

Playing with dolls and, in fact, recreating an entire camp through role playing was common. Children took the parts of mothers, fathers, enemies attacking a camp, and warriors defending it. In the Museum of the American Indian, Heye Foundation, there is a set of "play camp" toys, complete with human and animal figures and tipis (Lenz 1986, 42).

Dolls were also made for especially loved children as signs of esteem (Conn 1982, 139). Sometimes they were passed on to other particularly honored people. In 1930 the Reverend Frank Thorburn, Episcopal Minister of the Niobrara Deanery, District of South Dakota, was given a male doll by Mrs. Lulu White Eagle of Standing Rock. Her own son had recently died and she offered to become the Reverend's adopted mother, promising to take care of his tent, to bring him hot shaving water, and generally to look after him. The gift of the doll symbolized the closeness of their relationship (Thorburn 1986).

Dolls in cradleboards, such as Catalogue number 175, have appeared in museum collections since the mid 1800s. While dolls in cradles from the nineteenth century were probably made as toys for the children of the maker or her relatives or friends, many dolls were also later made for sale.

A variety of cradle types was developed by different Native American groups. Although they were often highly decorated, they were basically utilitarian. The cradle usually included some kind of stiff backing, a soft hide or cloth or wrap for warmth, a stiff hood or fender bar as protection for the head, and a hanging device so that the baby could be portable, carried on the mother's back with a tump line around the mother's forehead, or a strap around her shoulders and across her chest. Straps attached to the back of a cradle could be placed over the pommel of a horse's saddle. In a society in which babies were very much a part of all of the activities of everyday life, with no special areas set aside for them, these cradles provided protection, warmth, and a means of transportation for infants. The cradles became a symbol of the love of the family for the newly born. The highly decorated cradles were usually made by a female relative as a gift to the new baby, and decorated cradles were passed down as heirlooms in families.

The Crow style cradle (Cat. 69) is of a rounded, U-shaped construction shared with the Plateau and Basin people. It has a hide covering over board, and is bead embroidered at the top. Its wide, beaded straps, which lace to hold the baby firmly on the board, are unique to the Crow. Most of the documented Crow cradles of this style date from the 1880s. The beadwork design is of a style formerly considered classic Crow of the late nineteenth century. However, recent studies (Feder 1980; Lessard 1980; Loeb 1980) indicate that this style is common to Plateau and Great Basin groups as well and that the direction of its development is not yet clear.

The Ojibwa cradle (Cat. 70) is also backed with a solid board. It has a steamed bent-wood head-protector or fender, which also serves as a bar from which to hang a cloth sun shield and dangle toys for the protection and amusement of the child within. The infant was placed in the cradle so that its buttocks rested in a curved birchbark tray, which was filled with highly absorbent moss. This tray of moss served as a diaper. At intervals the band wrappings around the outside of the cradle were unfastened, and the tray was emptied and filled with fresh moss. Northern peoples to-

day still know where to gather this moss and remember how it was used. The cradle illustrated is unusual in being complete, with tray, decorative embroidered bands, inner cloth wrap, and a narrow dowel attached to one side, around which the cloth bands were wrapped to secure them.

The Central Plains soft cradle hood (Cat. 68) is of a type typical to both Cheyenne and Lakota peoples. Unlike the lattice cradles, which were mounted on two pointed sticks for convenience in transporting the infant, this is a soft cradle, suitable for holding the baby in the lap or rocking him to sleep. The decorated portion is the hood, which also serves as a protection for the baby's head. As mentioned earlier, the square rawhide tab that protrudes from the back of the hood is often decorated with designs of protective importance. In this example, the design of a turtle appears in the center of the tab, and the sacred number four is recalled in the four corner decorations. Also important for the protection of the baby against sickness or misfortune were the small, cloth-wrapped amulets that border the hood.

Continuity in dress style is well represented by the small girl's dress (Cat. 136) made by Mrs. Victor Little Chief (1875–1937) of the Northern Cheyenne Tribe, Lame Deer, Montana. Such documented dresses in museum collections show that the cut of the hide, the colors of beads, and the placement of bead rows has remained exactly the same for at least the last eighty-five years. For the child's protection, the dress is decorated with sophora seeds and with the four-pointed cross, which may represent the Morningstar, a Cheyenne culture hero, or the four cardinal directions. As proof that the dress was made for a much-loved child, the bodice is embroidered with carved bone or antler representations of elk teeth as well as a few real elk teeth. Since only the two milk teeth of an elk were used in decoration, clothing so ornamented was very prestigious. The girl who wore this dress knew that she had a strong protector who was either a very good hunter or wealthy enough to trade for the teeth.

Children's clothing was made just like that of adults, except that it was smaller. The lovely boy's hide coat (Cat. 137) with inserted fringing in this collection is cut in a European style, with fitted shoulders and waist. The porcupine quill floral embroidery is extremely delicate and well executed. Around the hem of the coat are quilled feather designs representing the "coups" or war honors that

the boy will earn when he is older. The boy's quilled vest (Cat. 131) is probably pow-wow wear. Its designs are larger than those in Catalogue number 137, indicating that it is probably made by the Lakota, who used a two-thread embroidery technique in which quills were folded back and forth between two parallel lines, resulting in a stiff, banded look in the floral quillwork. The quillwork on the boy's coat is executed in a two-thread technique also, but the bands are much narrower and the overall effect more delicate and more typical of Dakota or possibly Manitoba Cree work. Both of these groups were influenced by mixed blood or Metis styles, which showed much acculturation in the cut of clothing and in the delicate floral motifs.

A growing complexity of bead design occurred after 1870, especially among the Lakota people. The child's beaded vest (Cat. 126) exhibits geometric designs that have been elaborated with extensions of lines and forks, similar to Caucasian rug patterns. The two right triangles above the larger triangle have been called "clouds" by Oglala beadworkers (Lyford 1940, 74) while the larger isosceles triangles with stepped design interiors might be called "cut-outs" or "mountains," depending on whose design it is.

The Importance of Documentation

All objects have a history that helps us to understand something about the people who created them. While some objects are inherently beautiful and can become a part of the human treasury because of their aesthetic quality alone, other objects are important because of what their documentation tells us about their makers and their times. Unfortunately, the anthropological importance of objects is often lost through the years, as objects change hands and become separated from their history. This is particularly true of Plains collections, since they were widely dispersed through purchase by travellers to the west, as well as through frequent intertribal trading, raiding, and gift giving in the nineteenth century, and through the pow-wow circuit of the twentieth century.

The Rahr Collection is typical of many of the great camp collections of the late nineteenth and early twentieth centuries. Objects were purchased as a sign of appreciation of native art and to be enjoyed along with other fine works of art. They were displayed in striking decorative groupings

on the walls of log homes, often large and elaborate ones, in Wisconsin, Minnesota, Michigan, and further east in the Adirondacks. The Rahr's camp was on Tenderfoot Lake in Land of Lakes, Michigan, where they summered for many seasons. They collected Indian art objects for a period of nearly twenty-five years, with most of the collection in place before 1950. All of it was purchased or was a gift to Mr. Rahr from dealers and friends, some of whom had ties with the native population of the area. None of the pieces, however, was field collected from native people. As is common with North American materials, especially those from the Plains, little information accompanies the collection. The objects, then, must be identified on the basis of research using comparative collections that do have clear documentation, using as well photographs, artists' renderings, written reports of the times, and information gained from native consultants.

Since many styles and types of objects are common to large cultural areas that include a number of tribal groups, they cannot be identified with particular groups unless they have a specific accompanying history. It is thus often prudent to give attributions by area. Certain style centers existed that radiated influences in many directions. For instance, on the Northern Plains in the fourth quarter of the nineteenth century, a checkerboard design, executed in an overlay bead technique, was common to Plains Cree, Blackfoot, Sarsi, and Assiniboin people. Around 1885–1900 in the Plateau, Basin, and Northern Plains, a common geometric style based on a two-dimensional field was shared by the Crow, Nez Perce, Yakima, Flathead, Ute, and Eastern Shoshone. Conn has called this the "transmontane" style in order to include all of the groups who practiced it (Conn 1986, 128). In the Central Plains from about 1875 to 1910, the Lakota, Cheyenne, and Arapaho people used a lazy-stitch technique of beadwork to cover large areas of hide clothing with geometric designs, in primary colors, usually on white or blue fields. And in the Northeastern Plains in the second half of the nineteenth century, the Red River Metis intermingled with the Eastern Dakota and Cree people, making it difficult to determine the origin of much of the floral design in both quill and bead embroidery that resulted.

As with all Native American collections, one must be aware that re-creations of particularly strong and appealing status and ritual objects have been made to satisfy patron demand. Often re-creations were made with great care, using materials appropriate to the period, and so we cannot always determine whether they are the original "used" objects that had a place in the society of their time, objects created at a later date as archaisms but still for the enjoyment of native people, or objects re-created specifically for commercial purposes. Therefore, because we do not have collection information on the source of such ritual objects as the bison-horn staff (Cat. 50), the eagle-bone whistle (Cat. 10), and the split-horn bonnet (Cat. 179), we can study these pieces with an awareness of the significance of the rituals that inspired them but we cannot necessarily consider these particular examples as functional originals.

Objects in Transition: From Artifact of Culture to Art Object

Traditional art objects change in meaning when they are removed from the cultural setting in which they fulfilled a necessary role. This is obvious in native people's changing attitudes toward their creations when these creations have been removed from home or ritual use to exhibition in elite museum settings, becoming art objects devoid of cultural context. In order to enhance the understanding of museum visitors or readers of museum catalogues for the rationale of such objects, it is important to recall the dual nature of traditional art: that it serves a combined need, one that is both material (utilitarian) and immaterial (spiritual) in a given society. This need has been expressively fulfilled by Native American art, which has combined the functional with the beautiful, producing objects that are appropriate for their intended use and in harmony with their surroundings.

Coe, Ralph. *Lost and Found Traditions: Native American Art 1965–1985*. New York: The American Federation of Arts, 1986.

Conn, Richard. *Native American Art in the Denver Art Museum*. Denver: Denver Art Museum, 1979.

———. *Circles of the World: Traditional Art of the Plains Indians*. Denver: Denver Art Museum, 1982.

———. *A Persistent Vision: Art of the Reservation Days*. Denver: Denver Art Museum, 1986.

Dawson, L. E., Fredrickson, V. M., Graburn, N. *Traditions in Transition: Culture Contact and Material Change*. Berkeley: Lowie Museum, 1974.

Ewers, John. *Blackfeet Crafts.* Lawrence, Kans.: United States Dept. of the Interior, Bureau of Indian Affairs, 1945.

———. "Notes on the Weasel in Historic Plains Indian Culture." *Plains Anthropologist* 22, no. 78, pt. 1 (1977).

Feder, Norman. "Crow Indian Art: The Problem." *American Indian Art*, Winter 1980, 30–31.

Hail, Barbara. Fieldnotes, study of Manitoba Cree embroidery artists. 1985.

Hoffman, William J. "The Midewiwin or Grand Medicine Society of the Ojibwa." *Bureau of American Ethnology, 7th Annual Report.* Washington, D.C., 1891, 149ff.

———. "The Menomini Indians." *Bureau of American Ethnology, 14th Annual Report, pt. 1*, Washington, D.C., 1892–93.

Lenz, Mary Jane. *The Stuff of Dreams: Native American Dolls.* New York: Museum of the American Indian, 1986.

Lessard, F. Dennis. "Crow Indian Art: The Nez Perce Connection." *American Indian Art* 6, no. 1 (Winter 1980), 54–63.

Linderman, Frank. *Pretty-Shield: Medicine Woman of the Crows.* Lincoln, Neb.: University of Nebraska Press, 1972.

Loeb, Barbara. "Mirror Bags and Bandoleer Bags: A Comparison." *American Indian Art*, Winter 1980, 46–54.

Lurie, Nancy. *Mountain Wolf Woman, Sister of Crashing Thunder: The Autobiography of a Winnebago Indian.* Ann Arbor: University of Michigan Press, 1966.

Lyford, Carrie. "Quill and Beadwork of the Western Sioux." *Indian Hand Craft Pamphlet.* Lawrence, Kans.: U. S. Dept. of the Interior, Haskell Institute, 1940.

Mooney, James. "Smohalla and His Doctrine." In *The Ghost Dance Religion and the Sioux Outbreak of 1890*, ch. 7, pp. 716ff. *14th Annual Report, Pt. 2.* Washington, D.C.: Bureau of American Ethnology, 1896.

Murie, James R. "Ceremonies of the Pawnee." In *Smithsonian Contributions to Anthropology #27*, ed. D. R. Parks. Washington, D.C., 1981.

Powell, Peter. "Beauty for New Life." In *Native American Art*, ed. Evan Maurer, pp. 33–56. Chicago: Art Institute of Chicago, 1976.

Thorburn, Francis, and Abigail. Collection Notes, South Dakota Memorial Art Center, Brookings, S.D., 1986.

Whiteford, Andrew H. "The Origins of Great Lakes Beaded Bandolier Bags." *American Indian Art* 2, no. 3 (Summer 1986): 32–43.

Wildschut, W. and John Ewers. *Crow Indian Beadwork: A Descriptive and Historical Study.* Contributions, Museum of the American Indian, Heye Foundation, vol. 16. New York, 1959, pp. 1–55.

———. *Crow Indian Medicine Bundles.* Contributions, Museum of the American Indian, Heye Foundation, vol. 17. New York, 1975.

Wissler, Clark. "Decorative Art of the Sioux Indians." In *Bulletin of the American Museum of Natural History 18, part 3*, New York, 1904.

———. "Some Protective Designs of the Dakota." *Anthropological Papers of the American Museum of Natural History 1, part 1*, New York, 1907.

———. "Societies and Ceremonial Associations in the Oglala Division of the Teton-Dakota." In *Anthropological Papers of the American Museum of Natural History 9, part 1*, pp. 79, 92–94. New York, 1912.

Plates

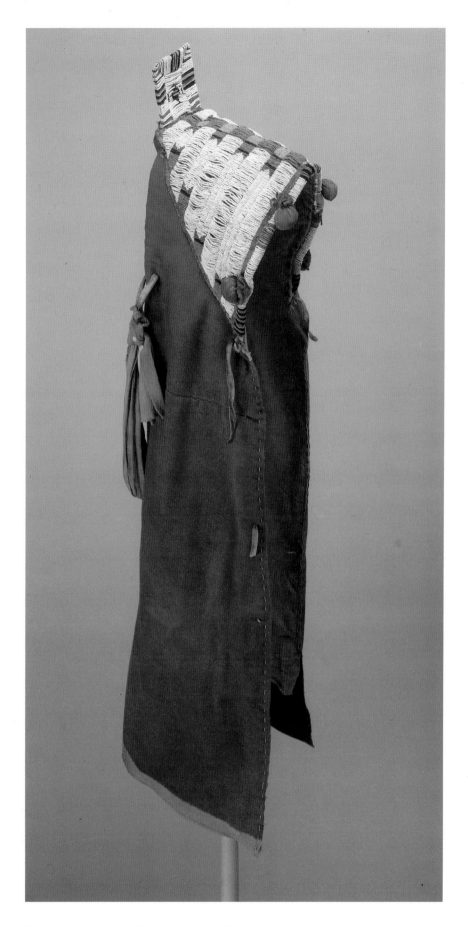

Baby Carrier. Central Plains: probably Cheyenne. Catalogue 68

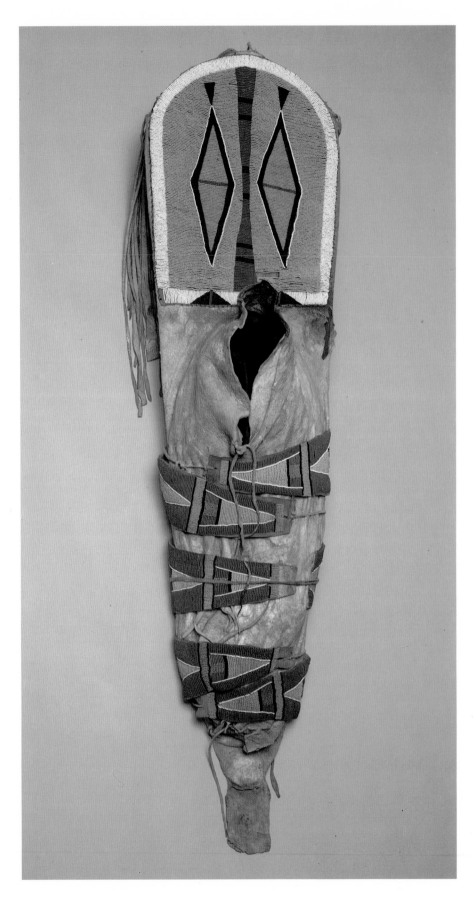

Baby Carrier. Northern Plains: Crow. Catalogue 69

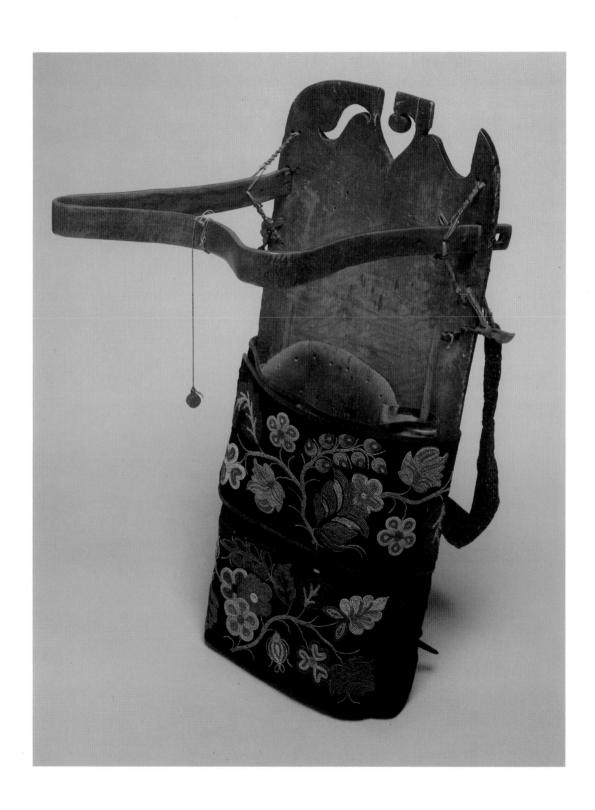

Baby Carrier. Great Lakes: Chippewa (Ojibwa). Catalogue 70

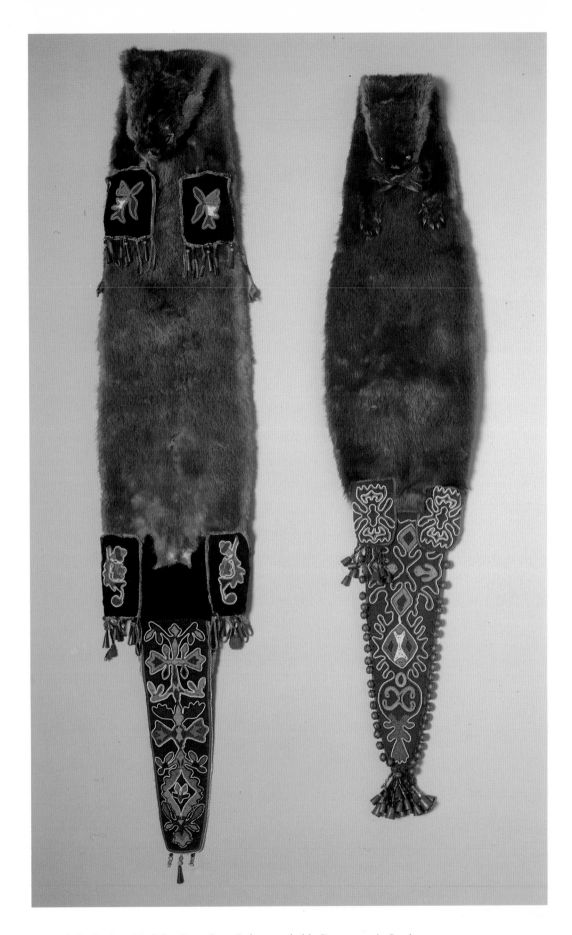

Midewiwin Society Medicine Bag. Great Lakes: probably Potawatomi. Catalogue 71

Midewiwin Society Medicine Bag. Great Lakes: possibly Menominee. Catalogue 72

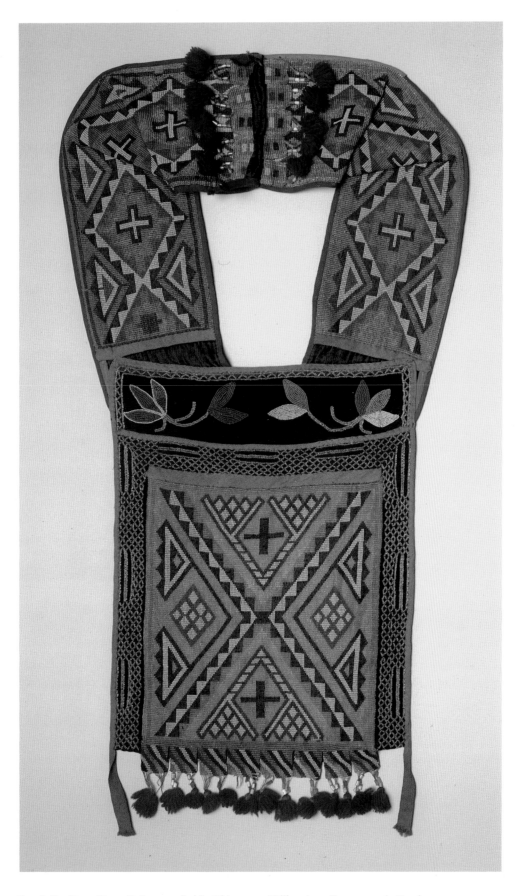

Bandolier Bag. Great Lakes: probably Chippewa (Ojibwa) or Potawatomi. Catalogue 110

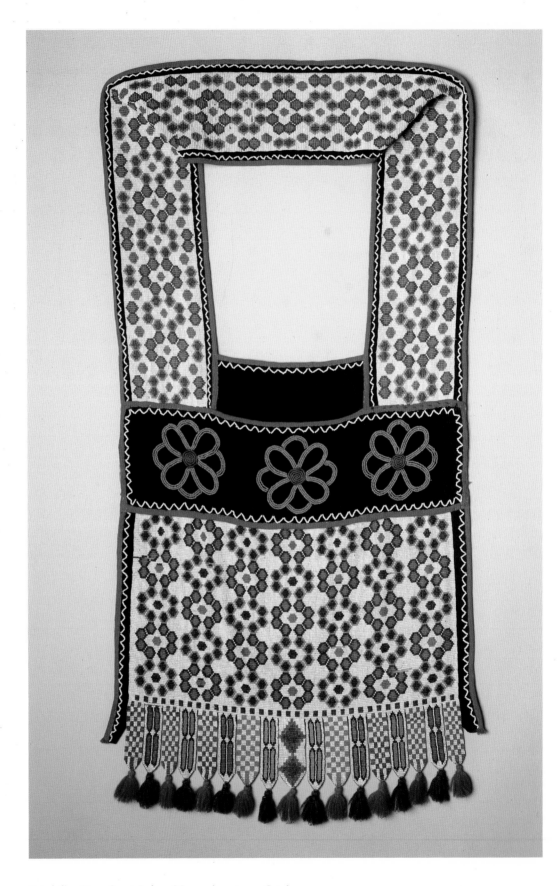

Bandolier Bag. Great Lakes: Menominee type. Catalogue 109

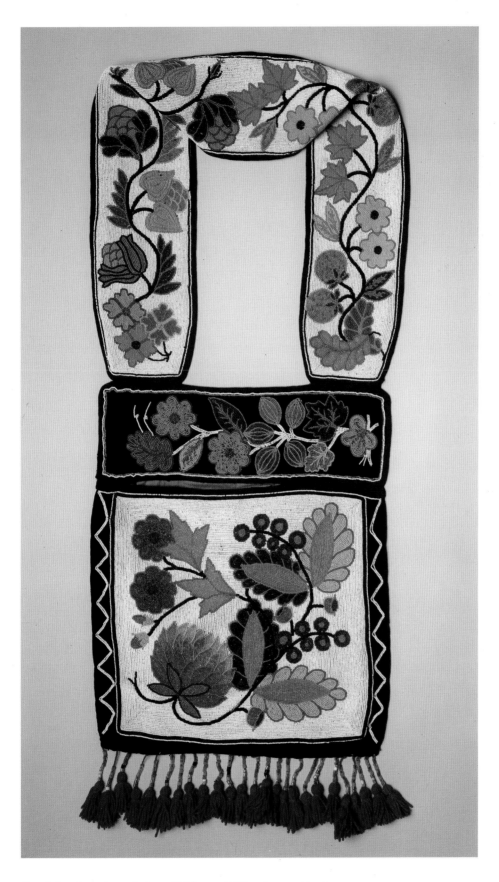

Bandolier Bag. Great Lakes: Chippewa (Ojibwa) type. Catalogue 108

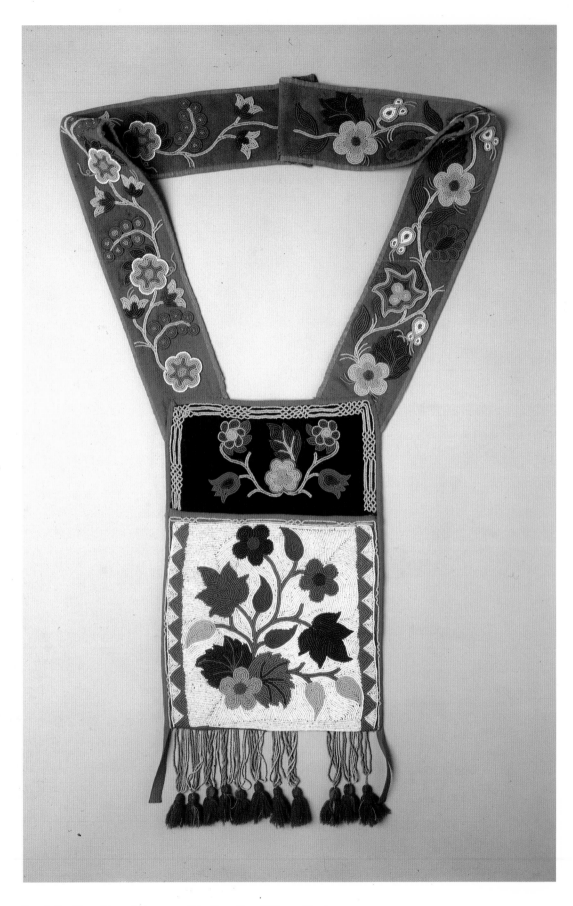

Bandolier Bag. Great Lakes: possibly Canadian Ojibwa. Catalogue III

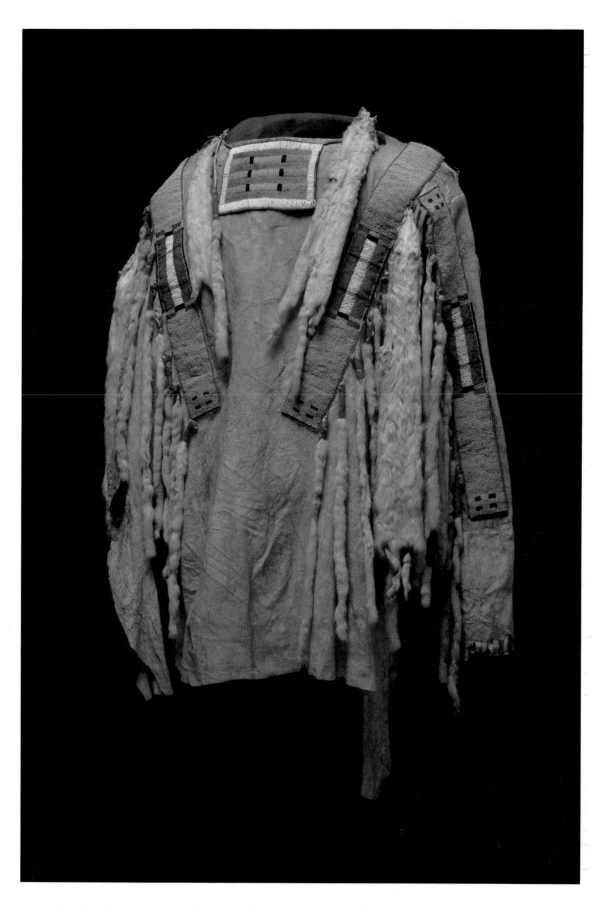

Man's Warshirt. Northern Plains: Crow. Catalogue 134

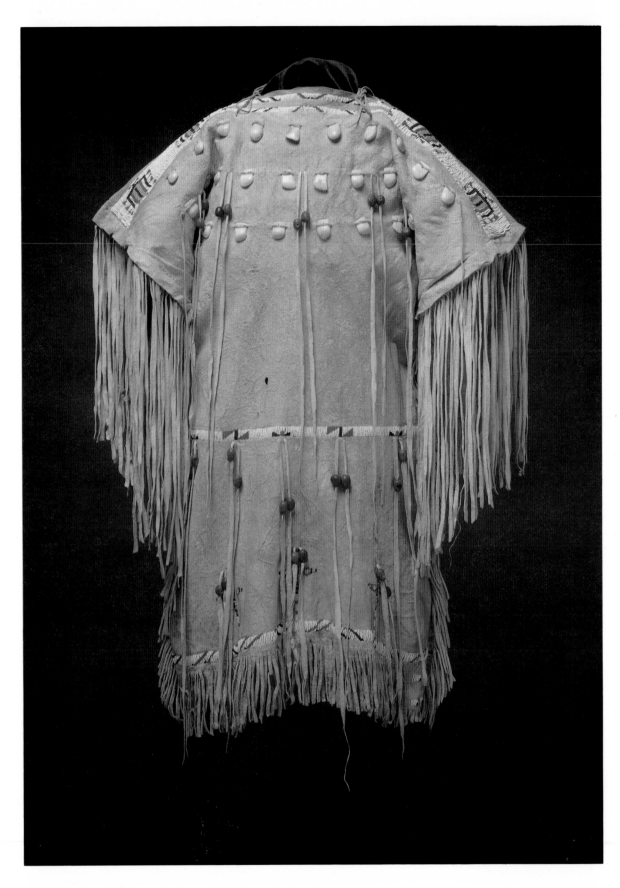

Girl's Dress. Central Plains: Northern Cheyenne, Lame Deer, Montana.
Made by Mrs. Victor Little Chief (1875–1937). Catalogue 136

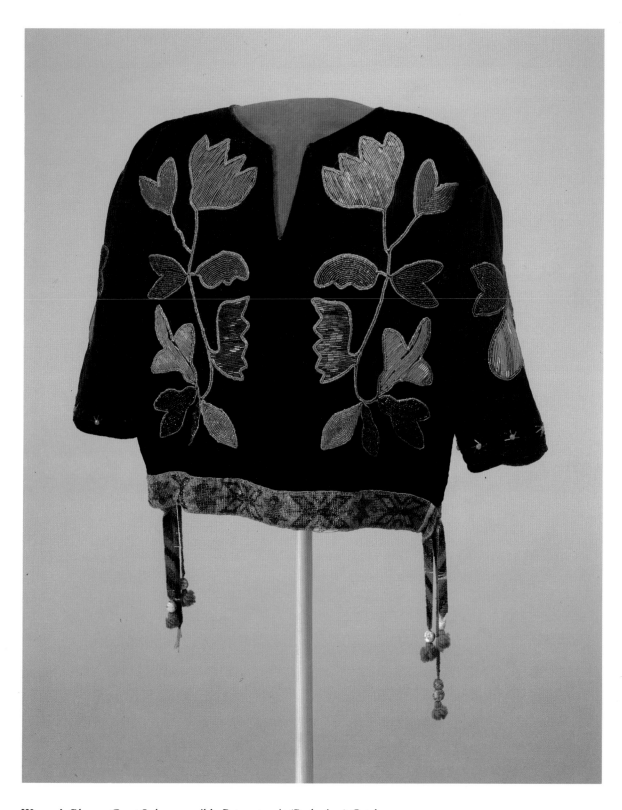

Woman's Blouse. Great Lakes: possibly Potawatomi. (Back view) Catalogue 133.

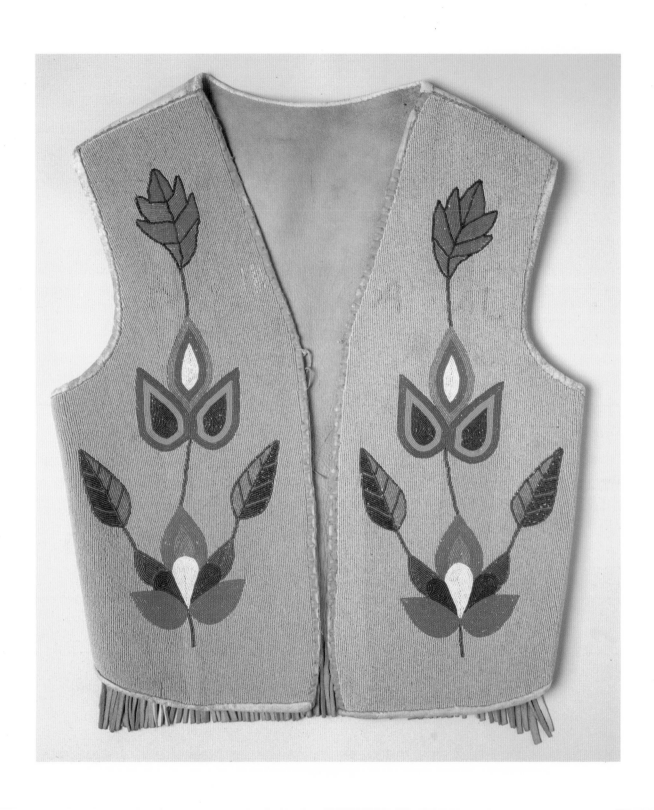

Man's Vest. Northern Plains/Intermontane. Catalogue 128

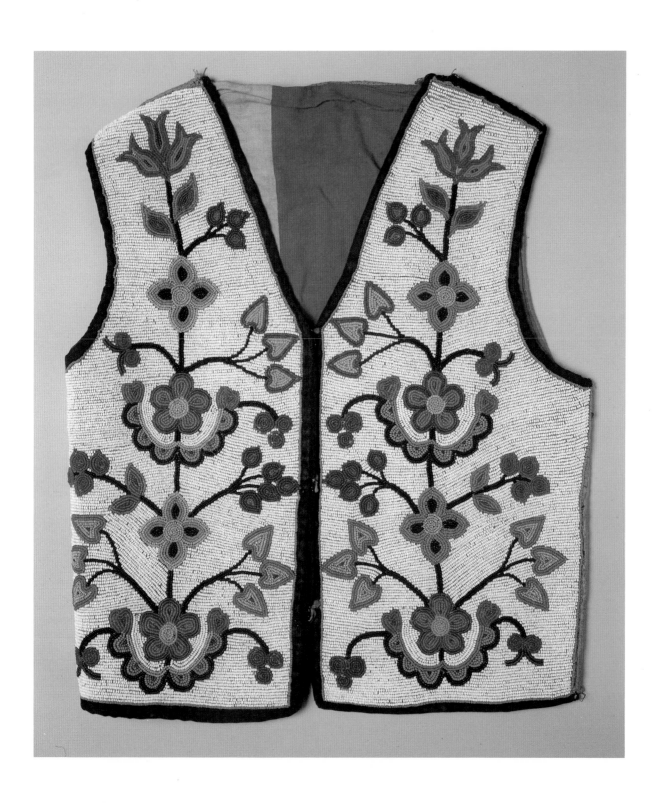

Man's Vest. Northern Plains: possibly Plains Cree. Catalogue 129

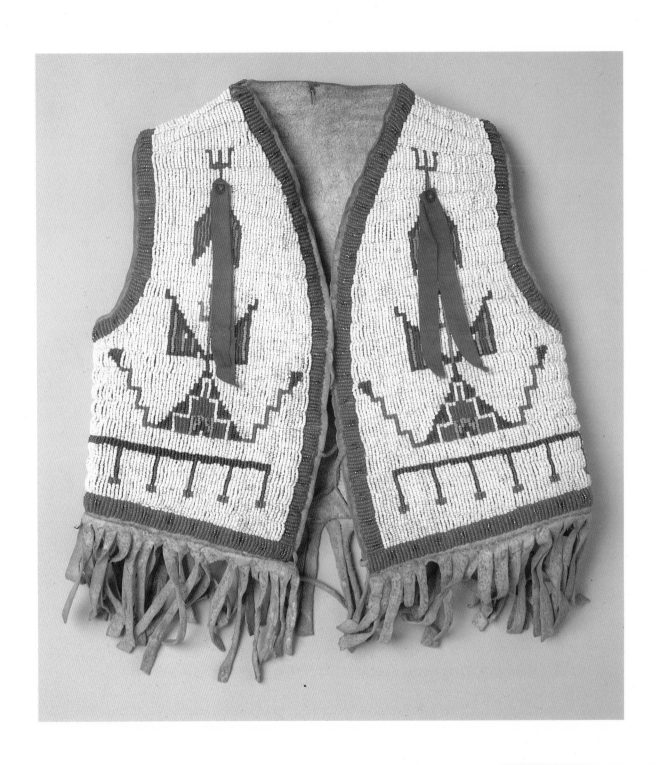

Boy's Vest. Central Plains: Lakota. Catalogue 126

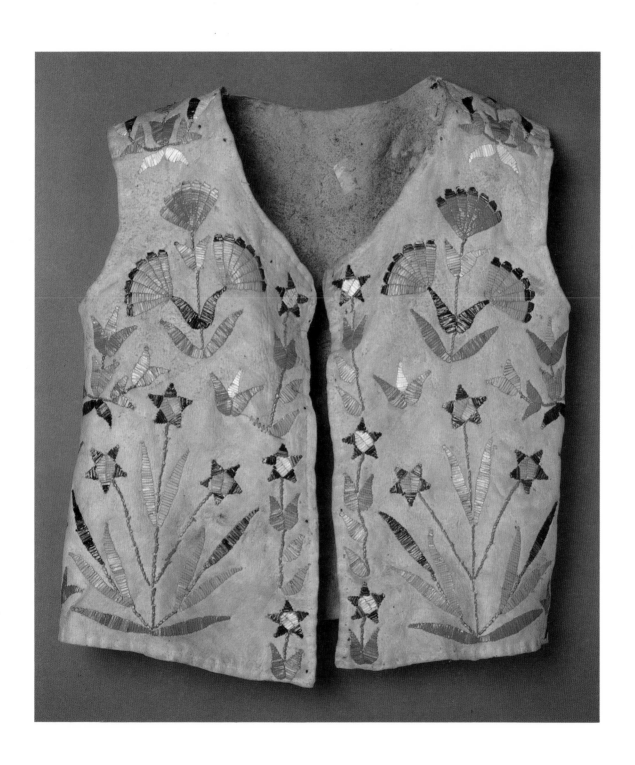

Boy's Vest. Central or Eastern Plains: Lakota or Dakota. Catalogue 131

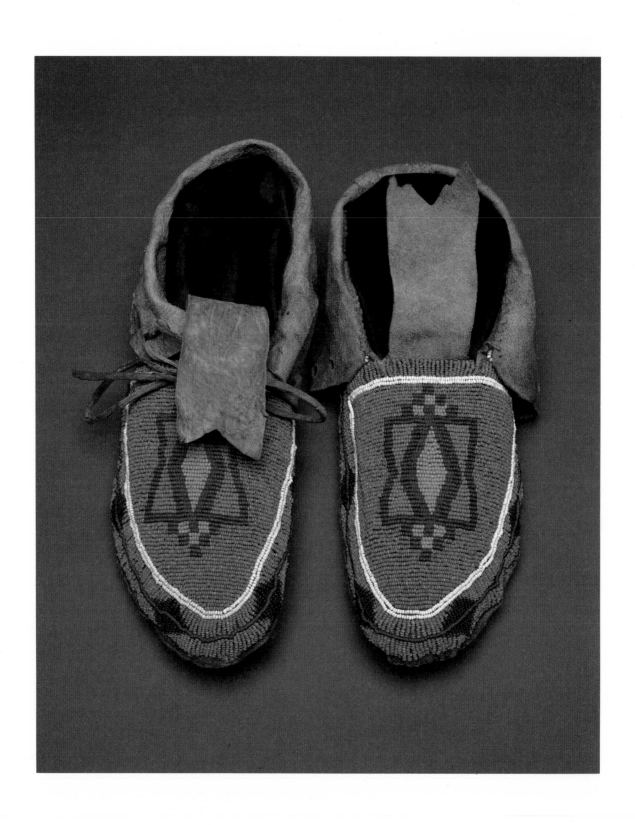

Moccasins. Northern Plains: probably Crow. Catalogue 155

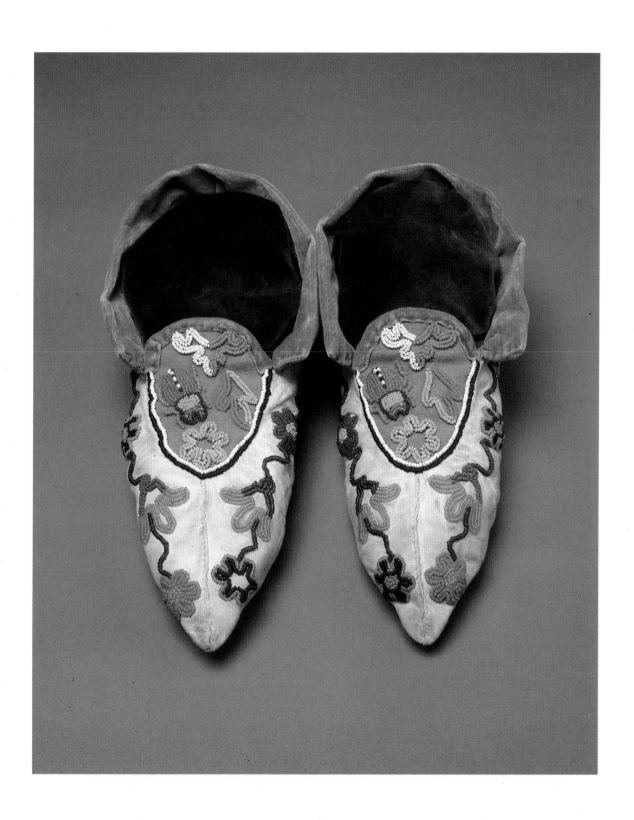

Woman's Moccasins. Northern Woodlands. Catalogue 172

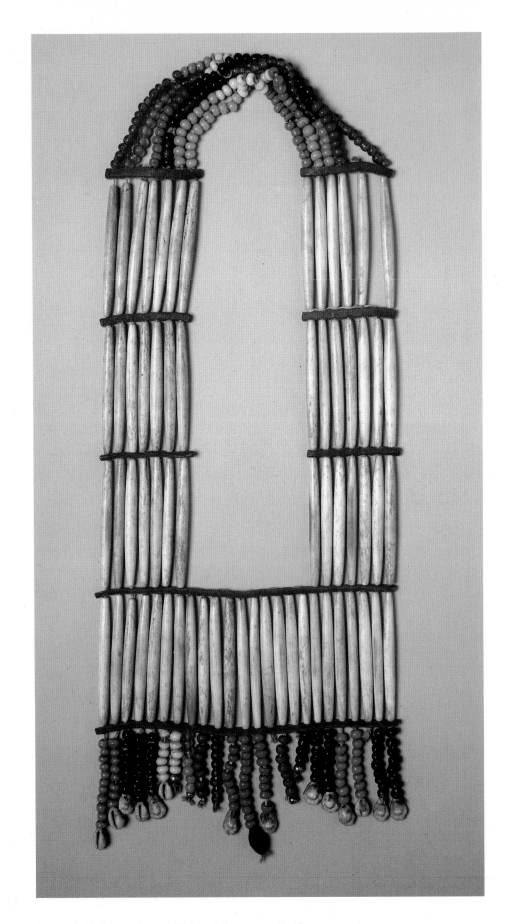

Woman's Necklace. Central Plains: Lakota type. Catalogue 139

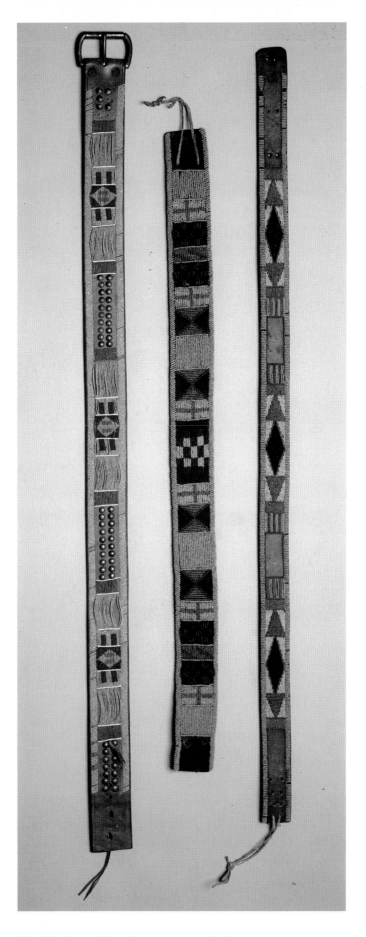

Belt. Northern Plains/Intermontane. Catalogue 114

Belt. Northern Plains: probably Flathead. Catalogue 115

Belt. Northern Plains. Catalogue 116

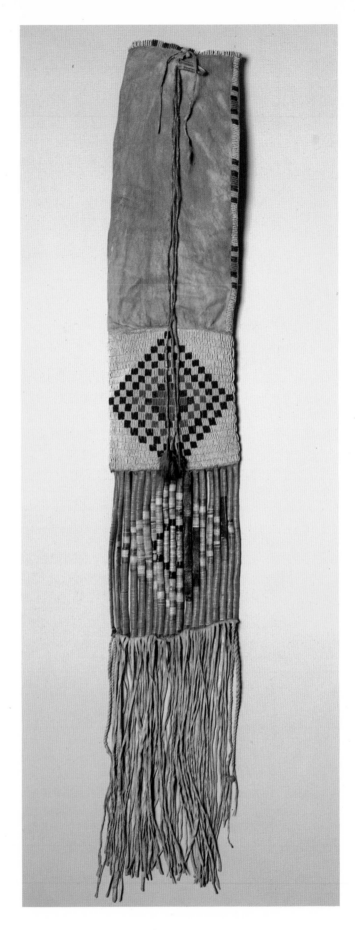

Pipe Bag. Central Plains: Lakota type. Catalogue 98

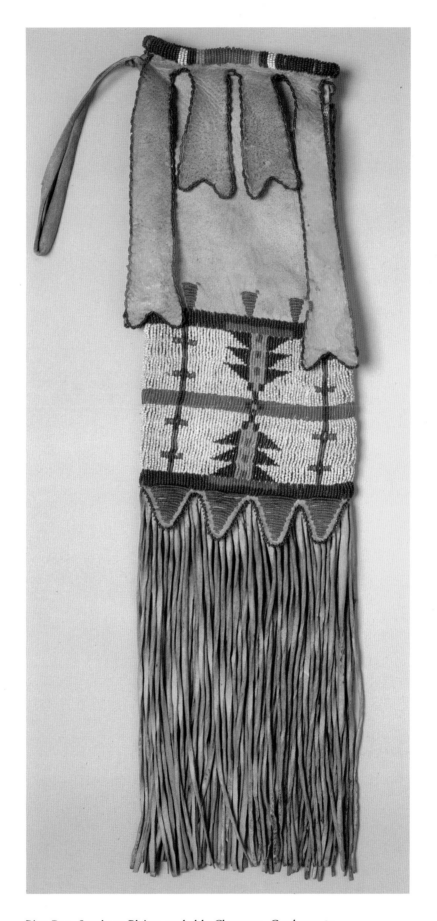

Pipe Bag. Southern Plains: probably Cheyenne. Catalogue 89

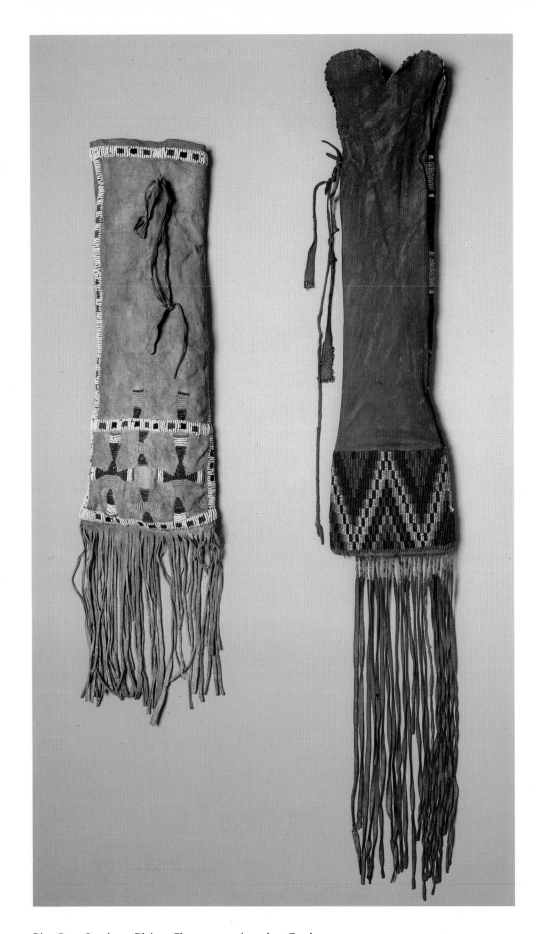

Pipe Bag. Southern Plains: Cheyenne or Arapaho. Catalogue 90

Pipe Bag. Northern Plains: possibly Blackfoot or Cree. Catalogue 93

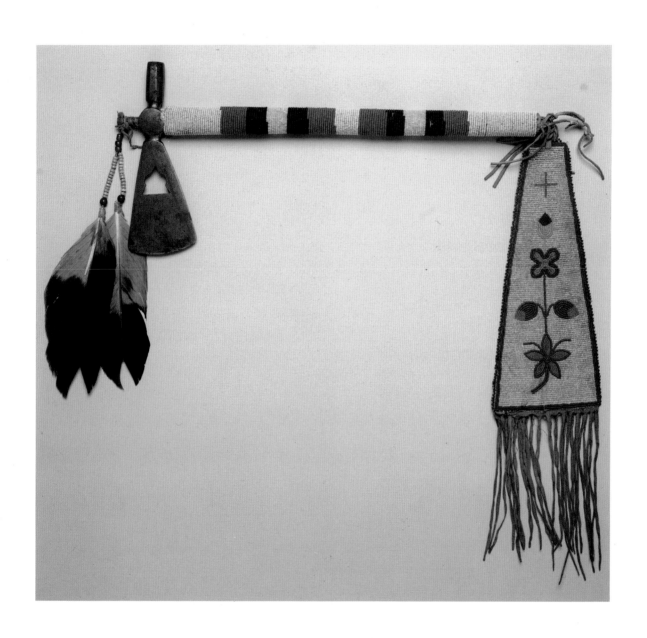

Tomahawk. Northern Plains: probably Plains Cree. Catalogue 20

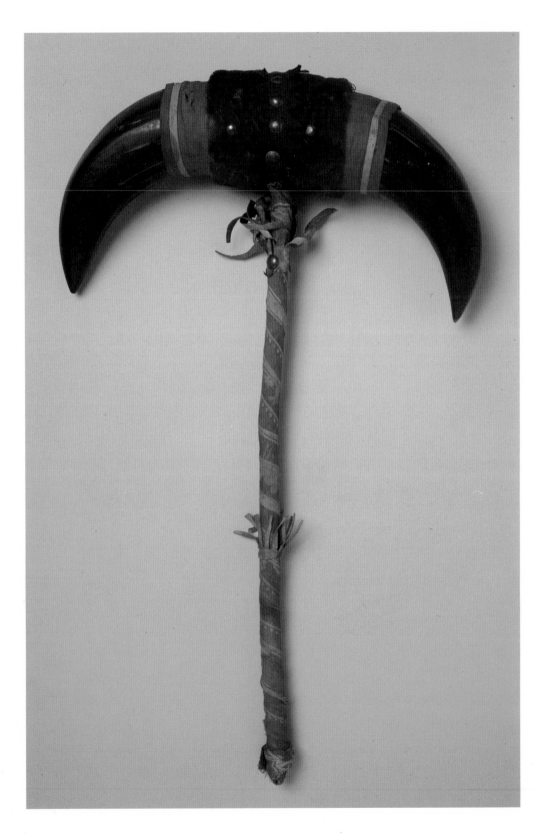

Ceremonial Staff. Plains. Catalogue 50

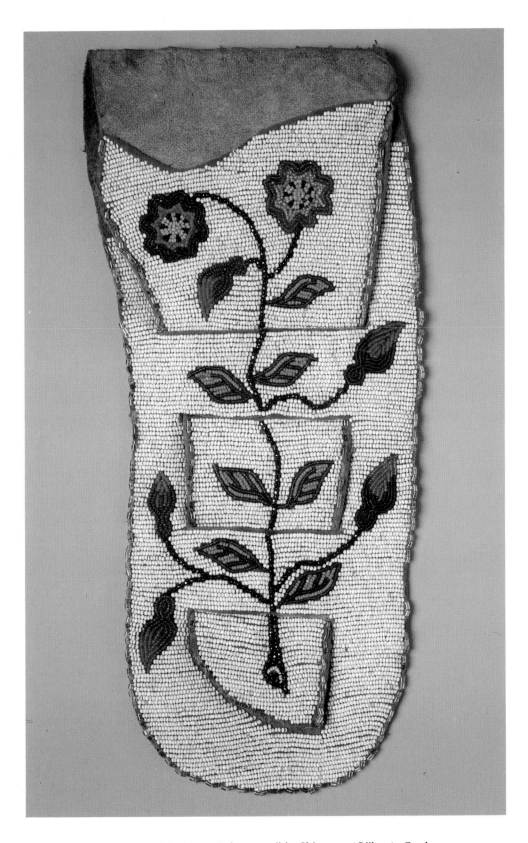

Pistol Holster. Northern Plains/Great Lakes: possibly Chippewa (Ojibwa). Catalogue 74

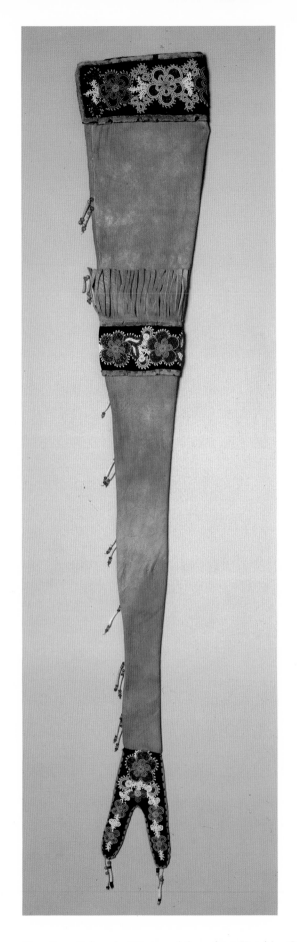

Gun Case. Subarctic: Western Athapaskan, Kutchin. Catalogue 104

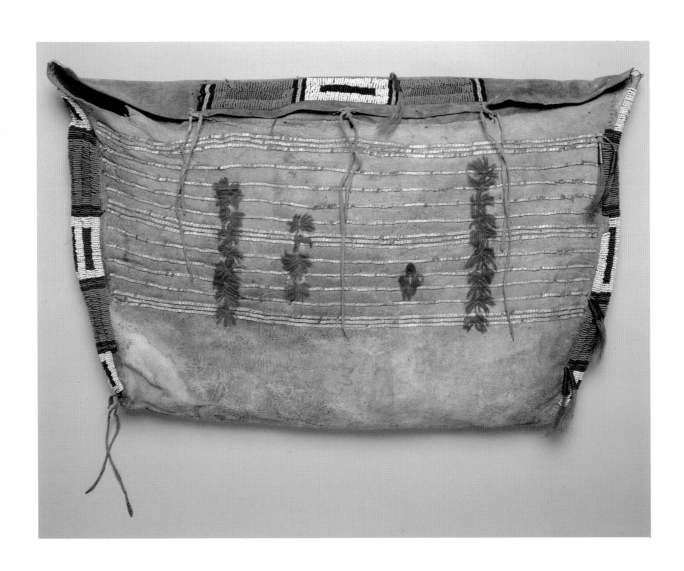

Storage Bag. Central Plains. Catalogue 66

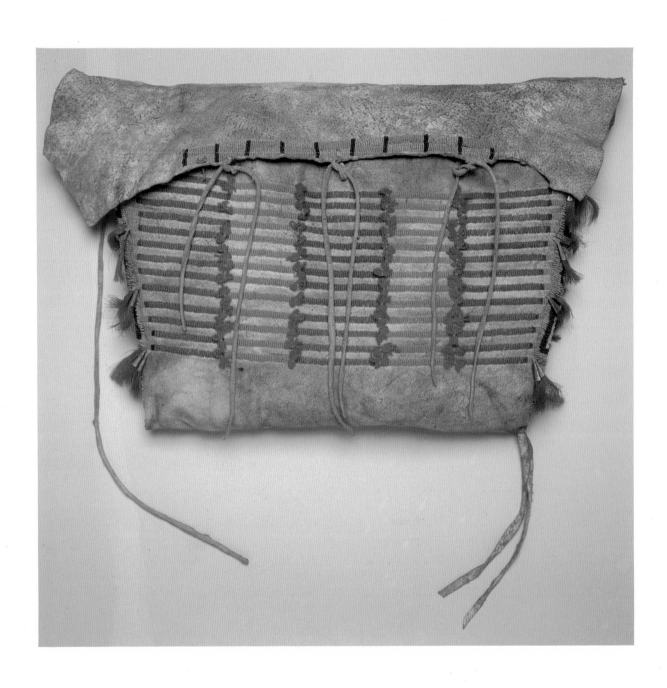

Storage Bag. Northern Plains: possibly Crow. Catalogue 67

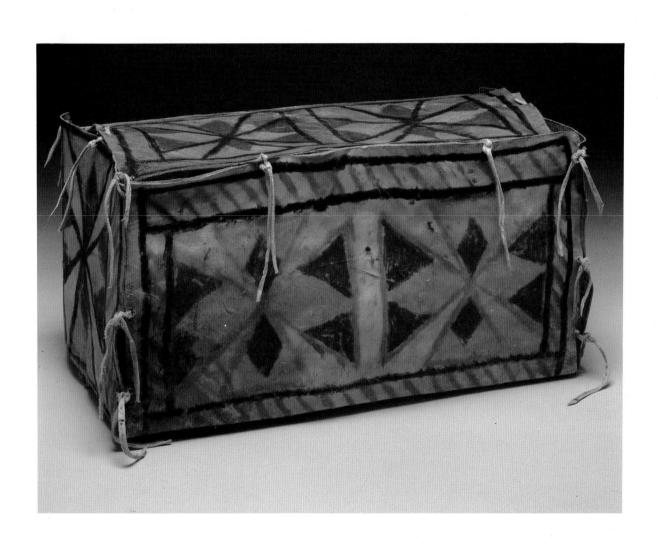

Storage Box. Eastern Plains: Siouan type, possibly Iowa. Catalogue 61

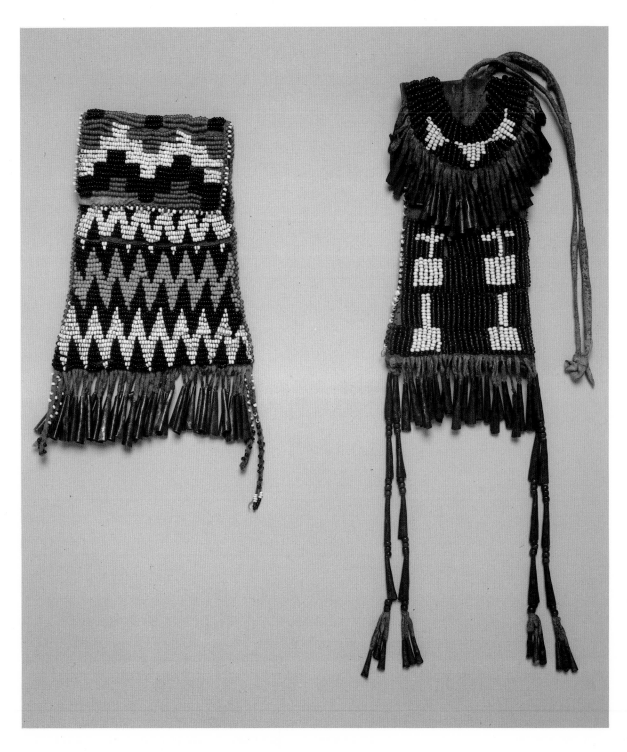

Strike-a-light Pouch. Southern Plains: Kiowa/Comanche. Catalogue 79

Strike-a-light Pouch. Southern Plains: Apache. Catalogue 80

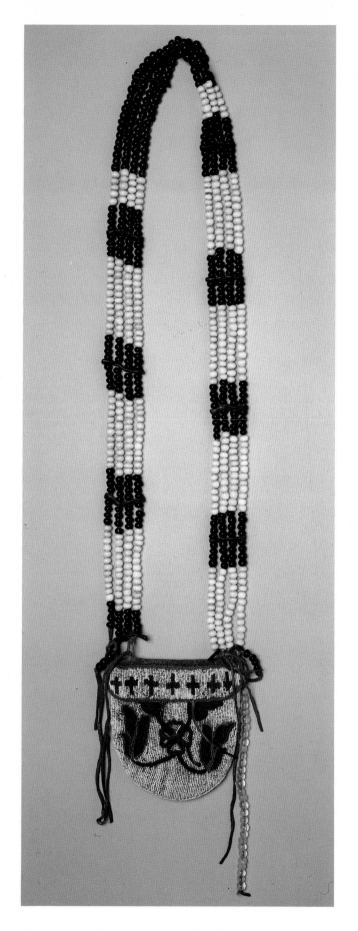

Shoulder Bag. Great Lakes: probably Chippewa (Ojibwa). Catalogue 106

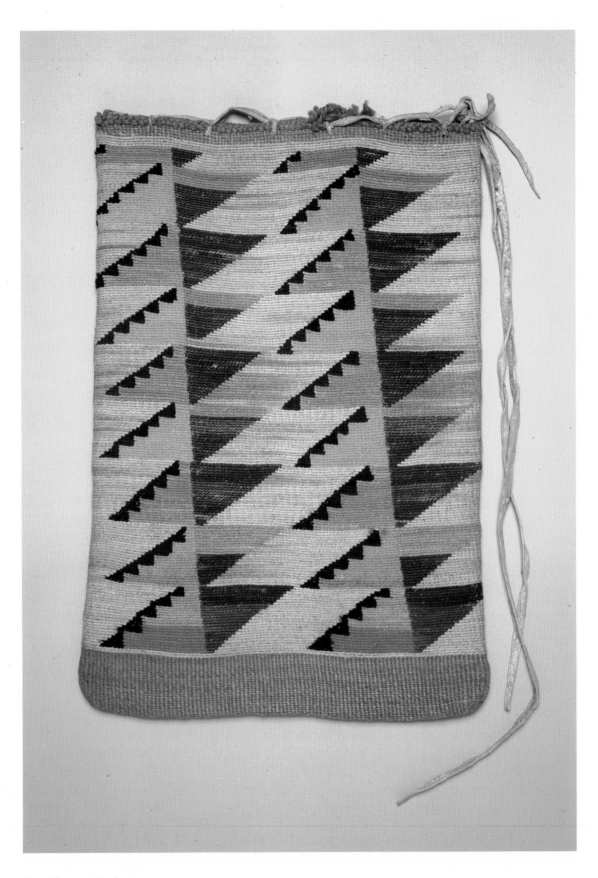

Bag. Plateau. Catalogue 64

Catalogue

Gregory C. Schwarz

Catalogue of the Guido R. Rahr, Sr., Collection

Unless otherwise noted, the provenance of all objects in this collection has been attributed by comparison with documented artifacts and consultation with reference works and authorities in the field.

Stars denote illustrated objects.

1. *Drum*
Southwest: New Mexico, probably Cochiti Pueblo
Early twentieth century
Wood, rawhide(deer), paint
53.8 cm. high, 31.0 cm. diameter
985.47.26464

2. *Drum*
Southwest: New Mexico, Cochiti Pueblo
Early twentieth century
Wood, rawhide (deer), paint
56.5 cm. high, 39.8 cm. diameter
985.47.26465

Drum marked "Cochiti." Cochiti Pueblo is well known for the manufacture of drums. When used, these drums hung from the player's belt.

3. *Drum*
Possibly Plains
Early twentieth century
Rawhide, metal, birch bark, pigment
9.0 cm. high, 30.0 cm. diameter
985.47.26466

Probably made for sale.

4. *Drum*
Probably Southwest: Pueblo
Early twentieth century
Rawhide, wood, pigment
5.1 cm. high, 26.2 cm. diameter
985.47.26467

Attached tag marked "Pueblo." Probably made for sale.

5. *Drum*
Southern Plains: possibly Comanche
Late nineteenth century
Rawhide, wood, pigment
7.2 cm. high, 24.5 cm. diameter
985.47.26468

Attached tag marked "Hand drum, Comanche."

6. *Rattle*
Southern Plains: probably Apache
Early twentieth century
Rawhide, steel, cloth, copper
4.2 cm. high, 22.4 cm. diameter
985.47.26469

Attached tag marked "Apache dance rattle." A metal wheel rim wrapped with rawhide is used as the rattle frame, and a length of Navajo weaving is attached to the inside.

7. *Rattle*
Plains
Early twentieth century
Native-tanned hide, rawhide, wood, cloth
127.0 cm. high, 8.2 x 9.0 cm. wide
985.47.26470

8. *Turtle-Shell Rattle*
Eastern Woodlands: Iroquois Type
Early to mid twentieth century
Turtle shell, wood, cloth, electrical tape
37.5 cm. high, 18.1 cm. wide
985.47.26471

The use of turtle shell for rattles is an Eastern Woodlands practice, especially common among the Iroquois.

9. *Turtle-Shell Rattle*
Eastern Woodlands: Iroquois type
Early twentieth century
Turtle shell, wood, commercial leather, pigment
34.2 cm. high, 13.5 cm. wide
985.47.26472

10. *Whistle*
Plains
Early twentieth century
Eagle bone, native-tanned hide (deer), porcupine
 quills, thread, sinew
20.3 cm. high, 2.2 cm. diameter
985.47.26473

11. *Peyote Fan*
Plains
Early twentieth century
Hawk feathers, wood, native-tanned hide, com-
 mercial leather, glass beads, metal, thread
35.0 cm. high (excluding fringe)
Gourd stitch beading technique
985.47.26474

Called singing fans by members of the Native American Church, these fans are held and gently shaken during the peyote ceremony as worshippers sing their prayers. Other accoutrements of the ceremony include a water drum made from a metal kettle and a beaded gourd rattle (Hail 1980).

12. *Pipe*
Southwest
Early twentieth century
Volcanic rock, wood, rawhide, metal, paint glass
 beads, feather
58.0 cm. high, 13.6 x 3.7 cm. wide
985.47.26475

Probably made for sale.

13. *Pipe*
Southwest
Early to mid twentieth century
Basalt, wood, rawhide, glass beads
59.4 cm. high, 11.8 x 4.0 cm. wide
985.47.26476

Stem marked "Indian Pipe, Arizona."
Probably made for sale.

14. *Pipe*
Southwest
Early twentieth century
Basalt, wood, commercial leather
45.1 cm. high, 7.0 x 6.0 cm. wide
985.47.26477

Probably made for sale.

15. *Pipe*
Southwest
Early twentieth century
Basalt, wood, commercial leather, feathers,
 rawhide, paint
57.0 cm. high, 5.0 x 12.1 cm. wide
985.47.26478

16. *Pipe*
Southwest
Early to mid twentieth century
Basalt, wood, rawhide
43.1 cm. high, 7.7 x 7.2 cm. wide
985.47.26479

Probably made for sale.

17. *Pipe*
Oklahoma
Mid twentieth century
Catlinite, wood, glass beads, commercial leather,
 thread
42.3 cm. high, 9.7 x 3.9 cm. wide
985.47.26480

Pipe bowl marked "Comanche Co. OKLA." The bowl is made of catlinite, a soft, red stone found in southwestern Minnesota. Named after the artist George Catlin, who visited the site in the 1830s, this stone has been used for centuries by Indians of the Northern Plains and Great Lakes to make pipes. During the nineteenth century, whites also quarried catlinite, and manufactured pipe bowls commercially for trade to Indians. Today, however, the place is a national monument, and only Native Americans are permitted to work the site. Pipes are still made, though primarily for the tourist trade, as was probably the case with this example.

18. *Pipe-Tomahawk*
European-made head,
Native-American-made shaft
Late nineteenth century
Brass, wood
41.8 cm. high, head: 18.9 x 3.0 cm. wide
985.47.26481

During the late 1600s, someone conceived the idea of combining a pipe with a blade, a combination that proved very popular among the Indians, joining as it did the pipe, an important ritual object, and the tomahawk, a symbol of war. Though it took the form of a weapon, this object's principle use was as a pipe or ornamental object. For this reason, some examples, such as this one, were made of brass or pewter.

19. *Pipe-Tomahawk*
Provenance unknown
Early twentieth century
Iron, wood, commercial leather
51.2 cm. high, head: 19.0 x 2.6 cm. wide
985.47.26482

Shaft marked: "Sioux Pipe Tomahawk, Oklahoma." A crude example, possibly made by an Indian blacksmith, this pipe was probably intended for sale to whites. An almost identical pipe-tomahawk, including similar carving on the shaft, is illustrated in Peterson (1971 Cat. 206) as "Prov. unknown post 1900."

*20. *Tomahawk*
Northern Plains: probably Plains Cree
European-made head, Native-American-made
 shaft
Late nineteenth to early twentieth century
Iron, wood, glass beads, cloth, thread
44.0 cm. high, head: 19.1 x 7.1 cm.
Overlay stitch beading technique
985.47.26483

By the seventeenth century, metal axes were one of the trade items most desired by Native Americans. Known as a "belt axe," "trade axe," or "tomahawk," these quickly supplanted the wooden club as the favored weapon for close combat. Axe heads came in many forms, with polls in the form of spikes, pipe bowls, or hammers as in this example. Besides their use for war, tomahawks, especially those with pipe bowls, also became objects of prestige, and were carried for ornamental purposes on special occasions. The design of the blade and the cutout of this piece indicate a late date of manufacture. The beadwork exhibits the somewhat stiff rendition of the floral motif typical of Plains Cree work.

21. *Club*
Eastern Woodlands
Early twentieth century
Wood, commercial leather, nails
48.2 cm. high, 14.9 x 9.0 cm. wide
985.47.26484

22. *Club*
Eastern Woodlands
Early twentieth century
Wood
50.5 cm. high, 10.4 x 7.2 cm. wide
985.47.26485

The word "tomahawk" originally referred to these ball-headed wooden clubs. Often made from a burl, this style of club was used throughout the Eastern Woodlands area prior to the introduction of the metal trade axe. Often these clubs were ornamented with carving, sometimes in the form of animals, and in some cases a stone or metal point was also inserted in the end of the ball. After metal axe blades became widely available in the eighteenth century, clubs such as this were only made as prestige objects or for the tourist trade.

23. *Club*
Eastern Woodlands
Early twentieth century
Wood
54.0 cm. high, 11.5 x 8.7 cm. wide
985.47.26486

Probably made for sale. The shaft has simple carved images of a snake, deer, canoe, bow and arrow, and an Indian.

24. *Club*
Eastern Woodlands
Early twentieth century
Wood
59.4 cm. high, 9.7 x 6.8 cm. wide
985.47.26487

Club marked "Charlevoix Co. Mich." Probably made for sale.

25. *Club*
Plains
Late nineteenth century
Stone, wood, rawhide (elk), sinew
109.8 cm. high, 13.2 x 7.2 cm. wide
986.45.26658

The traditional Plains-style warclub, which had a double-pointed stone head mounted on a rawhide wrapped shaft, was until the advent of firearms one of

the primary weapons used in combat. The head had a groove around the middle and usually a hole drilled at midpoint into which the end of the shaft fit. Meant to be used from horseback, clubs made for actual use had shafts at least two feet long. The shaft itself was made to be slightly flexible in order to increase the force of the blow. Besides serving as a weapon, clubs were also carried in dances and as ceremonial accoutrements.

26. *Club*
Plains
Late nineteenth to early twentieth century
Stone, wood, rawhide, thread
81.5 cm. high, 17.7 x 6.5 cm. wide
985.47.26488

27. *Club*
Plains
Stone, wood, rawhide
Late nineteenth century
85.0 cm. high, 10.4 x 7.2 cm. wide
985.47.26489

28. *Club*
Plains
Late nineteenth century
Stone, wood, rawhide, sinew, glass bead
76.8 cm. high, 12.4 x 5.6 cm. wide
985.47.26490

29. *Club*
Plains
Late nineteenth century
Stone, wood, rawhide, sinew
78.2 cm. high, 10.9 x 5.8 cm. wide
985.47.26491

30. *Club*
Plains
Late nineteenth to early twentieth century
Stone, wood, rawhide, cord
68.7 cm. high, 5.2 x 4.4 cm. wide
985.47.26492

Probably made for sale.

31. *Club*
Plains
Early twentieth century
Stone, wood, metal wire, rawhide, sinew
65.0 cm. high, 10.3 x 7.4 cm. wide
985.47.26493

A late example, probably made for sale, the club has a head secured to the shaft with heavy gauge wire.

32. *Club*
Plains
Late nineteenth to early twentieth century
Stone, wood, rawhide, sinew
62.0 cm. high, 13.2 x 5.6 cm. wide
985.47.26494

33. *Club*
Plains
Late nineteenth century
Stone, wood, rawhide, sinew, glass beads
84.0 cm. high, 10.8 x 6.5 cm. wide
985.47.26495

Marked "Walworth Co. S.D."
Probably made for sale.

34. *Club*
Plains
Early twentieth century
Stone, wood, rawhide, sinew, glass beads
71.0 cm. high, 14.5 x 9.1 cm. wide
Lazy stitch beading technique
985.47.26496

This heavy, unwieldy club, was probably made for sale. Indian weapons were especially popular among collectors, and many clubs were made during the reservation period to satisfy the demand for such souvenirs. Clubs made for the tourist trade are usually smaller and less sturdy than traditional weapons.

35. *Club*
Plains
Early twentieth century
Stone, wood, rawhide, sinew, commercial leather, pigment
62.3 cm. high, 15.5 x 4.3 cm. wide
985.47.26497

36. *Club*
Plains
Ca. 1930s–40s
Stone, wood, horsehair, porcupine quills
47.5 cm. high, 10.8 x 4.7 cm. wide
985.47.26498

Made for sale.

37. *Club*
Plains
Ca. 1930s–40s
Stone, wood, sinew, string
47.6 cm. high, 9.7 x 4.4 cm. wide
985.47.26499

Made for sale.

38. *Club*
Plains
Ca. 1930s–40s
Stone, wood, rawhide, glass beads, paint
45.8 cm. high, 7.2 x 4.7 cm. wide
985.47.26500

Made for sale.

39. *Club*
Plains
Ca. 1930s–40s
Stone, wood, rawhide, sinew, glass beads,
 commercial leather, feathers
48.5 cm. high, 8.6 x 4.2 cm. wide
Lazy stitch beading technique
985.47.26501

Made for sale.

40. *Club*
Plains
Early twentieth century
Stone, wood, rawhide, porcupine quills, sinew,
 pigment
58.0 cm. high, 10.8 x 6.7 cm. wide
985.47.26502

Made for sale.

41. *Club*
Plains
Ca. 1930s–40s
Stone, wood, horsehair, rawhide, paint
37.5 cm. high, 10.5 x 6.0 cm. wide
985.47.26503

Made for sale.

42. *Slungshot Club*
Plains
Early twentieth century
Rawhide (horse), wood, stone, horsehair
51.0 cm. high, 5.5 x 4.4 cm. wide
985.47.26505

When the weighted end was separated with a flexible
piece of rawhide, the striking force of the club was in-
creased. The horsehair decoration made this an appeal-
ing object to tourists. Many clubs, including this ex-
ample, were made for sale.

43. *Slungshot Club*
Plains
Late nineteenth to early twentieth century
Rawhide, wood, stone, horsehair
39.5 cm. high, 4.3 x 3.0 cm. wide
985.47.26506

Attached tag marked "Sitting Bull's." Dealers some-
times falsely attributed artifacts to famous Indians in
order to increase the selling price. It is quite possible,
however, that this club did pass through Sitting Bull's
hands. The famous Sioux Medicine Man frequently
sold his autograph, as well as other items, to souvenir
hunters. Many of the things he did sell he may have
owned only a short time, having obtained them from
other Indians for just that purpose. The Hood Mu-
seum collections contain several other objects said to
have been owned by Sitting Bull.

44. *Slungshot Club*
Plains
Early twentieth century
Rawhide (horse), wood, stone, horsehair
54.0 cm. high, 5.1 cm. diameter
985.47.26507

Probably made for sale.

45. *Slungshot Club*
Plains
Early twentieth century
Rawhide (horse), wood, stone, horsehair
37.0 cm. high, 5.7 x 3.3 cm. wide
985.47.26508

Probably made for sale.

46. *Slungshot Club*
Plains
Early twentieth century
Rawhide (calf), wood, stone, horsehair, glass
 beads, commercial leather, thread
29.0 cm. high, 5.0 x 3.2 cm. wide
985.47.26509

Probably made for sale.

47. *Rattle/Dance Staff*
Plains
Ca. 1930s–40s
Rawhide, wood, stone, horsehair
45.0 cm. high, 21.7 cm. wide
985.47.26510

48. *Ceremonial Staff*
Plains
Late nineteenth century
Cow horn, wood, rawhide
52.0 cm. high, 32.0 cm. wide
985.47.26511

Decorative clubs or staffs were carried by some members of Plains military societies during dances or special ceremonies. Many staffs were topped with bison horns in honor of the animal whose existence was so vital to the Plains Indians. Because of their ritual use in ceremonies, these horned staffs are sometimes called "dance wands," a term especially favored during the early part of this century.

49. *Ceremonial Staff*
Plains
Early twentieth century
Bison horn, wood, glass beads, horsehair,
 commercial leather, thread
52.0 cm. high, 23.0 cm. wide
985.47.26512

Because of their decorative and exotic appearance, horned staffs were popular tourist trade souvenirs, and many were made for this purpose.

50. *Ceremonial Staff
Plains
Late nineteenth to early twentieth century
Bison horns, wood, cloth, brass
52.0 cm. high, 31.5 cm. wide
985.47.26513

51. *Ceremonial Staff/Rattle*
Plains
Late nineteenth to early twentieth century
Cow horn, wood, rawhide, commercial leather,
 cloth, brass
48.5 cm. high, 36.3 cm. wide
985.47.26514

52. *Ceremonial Staff*
Plains
Late nineteenth to early twentieth century
Bison horn core, wood, rawhide, commercial
 leather
59.1 cm. high, 16.7 cm. wide
985.47.26515

53. *Pump Drill*
Southwest
Late nineteenth century
Wood, chert, native-tanned hide, sinew
36.0 cm. high, 8.0 cm. diameter
985.47.26516

Tipped with a stone or metal point, the drill was used by pumping the horizontal bar up and down. This caused the thongs to wrap and unwrap alternately around the shaft, turning the point first in one direction, then the other.

54. *Bow*
Arctic or Subarctic
Mid to late nineteenth century
Wood, sinew
158.0 cm. high, 3.8 x 3.0 cm. wide
985.47.26517

In the far north, driftwood was often the only means of obtaining wood. Since little of this material was really suitable for bowmaking, the native people were required to strengthen their bows by backing them with a cord of braided sinew.

55. *Bow*
Southwest: Apache
Mid to late nineteenth century
Wood, sinew
108.5 cm. high, 3.2 x 2.0 cm. wide
985.47.26518

Bow marked "Apache." Instead of using a cord backing to provide strength as in the Arctic, the Apache wrapped the entire bow with a sheet of sinew.

56. *Decorative Shield*
Plains
Early twentieth century
Rawhide (cow), wire, metal cones, paint
36.0 cm. diameter, 1.4 cm. wide
985.47.26519

Shields were originally made of rawhide, carefully dried and shrunk to form a thick, dense mass capable of turning arrows and even musket balls. By the mid nineteenth century, modern firearms had made shields obsolete for warfare, but they continued to retain their symbolic importance. Images painted on the front were usually spirit pictures derived from visions experienced by the owner, and it was believed their use helped protect him during battle. Decorative and appealing objects, many shields were, and still are, made for sale, some by non-Indian hobbyists, as may have been the case with this example.

57. *Shield*
Plains
Late nineteenth to early twentieth century
Commercial leather, feathers, paint
40.5 cm. diameter, 0.9 cm. wide
985.47.26520

Possibly made for sale.

58. *Horse Halter*
Plains
Late nineteenth to early twentieth century
Commercial leather, rawhide, horsehair, wool
 yarn
26.5 cm. high, 15.0 cm. wide (excluding rope)
985.47.26521

59. *Storage Box*
Plains: Siouan type
Late nineteenth to early twentieth century
Rawhide (cow), native-tanned hide, pigment
18.5 cm. high, 43.5 cm. wide, 22.0 cm. deep
985.47.26522

Unsuitable for transporting objects on horseback, rectangular storage boxes were made by Siouan speaking groups who had given up a nomadic lifestyle and were settled on reservations. The idea for such containers was probably borrowed from the Algonkians to the east, who being a sedentary people, had made similar boxes at an earlier date. These boxes were in turn a carryover from the containers of birchbark traditionally used. Algonkian boxes were made by being folded from a rectangular piece of hide with no edge seams, while the Siouan type is based on a cross-shaped hide piece with laced edges as this example demonstrates.

60. *Storage Box*
Plains: Siouan type, Lakota
Late nineteenth to early twentieth century
Rawhide (cow), native-tanned hide, pigment
21.0 cm. high, 41.0 cm. wide, 21.0 cm. deep
985.47.26523

*61. *Storage Box*
Eastern Plains: Siouan type, possibly Iowa
Late nineteenth to early twentieth century
Rawhide (cow), native-tanned hide, pigment
17.0 cm. high, 35.5 cm. wide, 16.0 cm. deep
985.47.26524

The design motifs and manner of construction are similar to an Iowa example illustrated in Morrow 1975, 224.

62. *Bag*
Plateau
Late nineteenth to early twentieth century
Jute twine, cornhusk, wool yarn
28.5 cm. high, 23.7 cm. wide
985.47.26525

By the turn of the century some weavers had begun to use commercially made jute twine instead of hemp, as is evident in this example (Gogol, 1980).

63. *Bag*
Plateau
Late nineteenth to early twentieth century
Hemp, cornhusk, wool yarn
49.5 cm. high, 38.0 cm. wide
985.47.26526

Dating from pre-contact time, these containers were traditionally used by women for gathering and storage of foodstuffs. The serviceable form and aesthetic appearance of the bags made them become desirable trade items, and they are found throughout the Columbia Plateau. The use of cornhusks as a decorative element in the weaving began in the mid nineteenth century with the arrival of white settlers. Their availability and ease of dyeing made the husks preferable to the bear grass previously used. Later, wool yarn was also added to create more complex motifs. Still made today, these bags no longer have a utilitarian function. Instead they serve as decorative accessories to a Plateau woman's dress costume. Though usually thought of as Nez Perce, cornhusk bags were also made by other Plateau peoples, and it is difficult to attribute them to a particular group (Gogol 1980, 4–10).

*64. *Bag*
Plateau
Late nineteenth to early twentieth century
Hemp, cornhusk, wool yarn
51.0 cm. high, 35.5 cm. wide
985.47.26527

65. *Storage Bag*
Central Plains: Lakota type
Late nineteenth century
Native-tanned hide, canvas, glass beads, metal,
 horsehair, sinew
38.0 cm. high, 55.0 cm. wide
Lazy stitch beading technique
985.47.26528

Heavy cloth substituted for hide when the latter was in short supply. A well-made example, this bag exhibits a classic Lakota beadwork motif.

*66. *Storage Bag*
Central Plains
Ca. 1870s
Native-tanned hide (bison calf), glass beads, porcupine quills, wool yarn, horsehair, metal, sinew
Lazy stitch beading technique
36.5 cm. high, 60.0 cm. wide
985.47.26529

*67. *Storage Bag*
Northern Plains: possibly Crow
Late nineteenth to early twentieth century
Native-tanned hide (deer), glass beads, wool yarn, metal, horsehair
34.5 cm. high, 56.0 cm. wide
Lazy stitch beading technique
985.47.26530

Used as a general-purpose container, these were often called "possible bags" by collectors and traders. The name is from the Sioux term which literally translated means "a bag for every possible thing" (Conn, 1979, 152). The striped beadwork motif is associated with girls' puberty rights.

*68. *Baby Carrier*
Central Plains: probably Cheyenne
Pre 1880
Native-tanned hide (bison), cloth, glass beads, wood, sinew, thread
64.0 cm. high, 29.0 cm. wide
Lazy stitch beading technique
985.47.26531

Old museum collection number "22558/52.60." Beadwork from the Central Plains is usually done using the "lazy stitch" technique. Instead of every bead being sewn on individually, each stitch, one-half inch to an inch in length, contains a number of beads. Though the result is less sturdy, the "lazy stitch" is quicker and requires less effort than other methods.

*69. *Baby Carrier*
Northern Plains: Crow
Late nineteenth century
Native-tanned hide (deer, bison), wood, glass beads, sinew, thread
112.0 cm. high, 29.5 cm. wide
Overlay stitch beading technique
985.47.26532

The beading on this carrier exhibits the distinctive color and geometric motifs used by the Crow during the late nineteenth century. It is done in the "overlay stitch" commonly used among Northern Plains groups. With this technique, each bead is separately sewn to the backing. While more time consuming, the resulting beadwork is more serviceable and less susceptible to damage than objects done in lazy stitch. While it is often hard to differentiate among the beadwork designs of neighboring groups, baby carriers can usually be distinguished. Crow carriers are identified by the U-shaped beaded frame and the three pairs of beaded straps used to secure the baby. One pair crossed the baby's chest, another pair the waist, and the lowest straps secured the ankles. Usually carried on a woman's back by means of a tump line, the cradle might also be slung from the saddle when the mother travelled by horseback. While this way of being carried might seem to be uncomfortable, reports from Indian mothers indicate that babies like being tightly wrapped and often cry to be put back in the carriers (Lessard 1980).

*70. *Baby Carrier*
Great Lakes: Chippewa (Ojibwa)
Late nineteenth century
Wood, birchbark, cloth, glass beads, hide, iron nails, catlinite, lead, thread
75.3 cm. high, 31.4 cm. wide, 42.8 cm. deep
Overlay stitch beading technique
985.47.26533

The baby carrier served to keep infants both comfortable and secure while the mother tended to her chores. The cradleboard could be carried on the mother's back or propped up. The projecting fender protected the child if the carrier fell forward, and small objects, such as the piece of catlinite, could be hung from it to amuse the child. When the infant was very small, it was placed in an adjustable birchbark seat tied onto the carrier. Moss was usually used as an absorbant, and was said to remain fragrant even when soiled. A wooden rod loosely attached to one side of the board was used for attaching the beaded cloth strips. Two strips were used, rather than one wide one, so that the baby could be attended to without undoing both wrappings (Densmore 1929).

*71. *Midewiwin Society Medicine Bag*
Great Lakes: probably Potawatomi
Late nineteenth century
Otter skin, glass beads, cloth, metal, thread
139.5 cm. high, 23.5 cm. wide
Overlay stitch beading technique
985.47.26534

Beading style suggests a Potawatomi origin for this bag.

*72. *Midewiwin Society Medicine Bag*
Great Lakes: possibly Menominee
Late nineteenth century
Otter skin, glass beads, cloth, brass thimbles and
 hawk bells, feathers, thread
Overlay stitch beading technique
985.47.26535

Otter-skin bags were made by many Great Lakes
groups for use by members of the Midewiwin medicine
society, a religious organization whose members used
rituals and herbal medicines to cure the sick. These
bags, made with a slit in the front, were used to hold
the medicine as well as other objects used in the Mide-
wiwin ceremonies. While they were usually made of ot-
ter pelts, the skins of mink and weasel, as well as other
animals were also used and are thought to represent
the different degrees reached by the owner within the
Midewiwin society. Bags were often decorated with
feathers, bells, and tinklers, which gave an air of move-
ment and life to the otter skin (Harrison 1986).

73. *Awl Cases*
Northern Plains
Late nineteenth to early twentieth century
Rawhide, native-tanned hide, commercial leather,
 glass beads, sinew
19.2–41.0 cm. high
Lazy stitch beading technique
985.47.26536–40

One of several pouches carried by women on their
belts, these cases held the bone or metal awls necessary
for sewing with leather. These examples, round in cross
section and made of one piece of hide, are typical of
those found in the Northern Plains. The southern type
are constructed of two pieces of hide sewn together
and would be oval in cross section. By the early twen-
tieth century, awl cases served essentially as decorative
accoutrements to a woman's dress costume and usually
only contained a pointed stick, placed there to preserve
the shape of the case.

*74. *Pistol Holster*
Northern Plains/Great Lakes: possibly Chippewa
 (Ojibwa)
Early to mid twentieth century
Native-tanned hide (elk), glass beads, thread
30.0 cm. high, 13.5 cm. wide
Overlay stitch beading technique
985.47.26541

Probably commissioned by a white client.

75. *Knife Sheath*
Northern Plains: possibly Cree
Late nineteenth century
Native-tanned hide (bison), glass beads, thread
33.5 cm. high (including fringe), 9.8 cm. wide
Overlay stitch beading technique
985.47.26542

76. *Knife Sheath*
Central Plains: Lakota type
Pre 1880
Native-tanned hide (bison), glass beads, sinew
38.0 cm. high (including fringe), 7.0 cm. wide
Lazy stitch beading technique
985.47.26543

77. *Knife Sheath*
Central Plains: Lakota type
Late nineteenth century
Rawhide, glass beads, sinew
24.6 cm. high, 6.3 cm. wide
Lazy stitch beading technique
985.47.26544

Made with rawhide cut from old parfleche.

78. *Knife Sheath*
Central Plains: possibly Lakota
Late nineteenth century
Native-tanned hide (deer), glass beads, sinew
13.1 cm. high, 5.3 cm. wide
Lazy stitch beading technique
985.47.26545

*79. *Strike-a-light Pouch*
Southern Plains: Kiowa/Comanche
Ca. 1851
Commercial leather, glass beads, metal, sinew
28.5 cm. high, 7.8 cm. wide
Lazy stitch beading technique
985.47.26546

Plains women traditionally carried on their belt several
pouches containing necessary household tools. Pouches
of the size and shape of this example held pieces of flint
and steel for starting fires, hence the name. During the
reservation period, these containers also served to hold
cardboard ration tickets. The use of commercial leather,
often taken from old boots, is typical of Southern
Plains leatherwork. Pouch construction and beadwork
style identify this example as Kiowa or Comanche. In-
scribed on the reverse is, "Camango Ind. Tejas Henry
Wagner 1851." "Camango" was probably a colloquial or
corrupted term indicating the Comanche.

*80. *Strike-a-light Pouch*
Southern Plains: Apache
Late nineteenth century
Commercial leather, glass beads, metal cones,
 sinew
19.5 cm. high (including fringe), 10.5 cm. wide
Lazy stitch beading technique
985.47.26547

81. *Strike-a-light Pouch*
Central Plains
Late nineteenth century
Commercial leather, glass beads, metal, bone,
 cowrie shells, sinew
25.0 cm. high (including fringe), 11.0 cm. wide
Lazy stitch beading technique
985.47.26548

82. *Pouch*
Plains
Late nineteenth to early twentieth century
Native-tanned hide, glass beads, ribbon, sinew,
 thread
20.3 cm. high (including fringe), 10.6 cm. wide
Lazy stitch beading technique
985.47.26549

Put together from pieces of other objects.

83. *Pouches*
Southern Plains/Southwest
Early to mid twentieth century
Native-tanned hide (deer), glass beads, metal,
 thread
12.8–27.0 cm. high
Netted beading
985.47.26550–2

Probably made for sale.

84. *Woman's Belt Pouch*
Plateau
Early to mid twentieth century
Native-tanned hide, glass beads, cloth, thread
12.2 cm. high, 12.2 cm. wide
Overlay beading technique
985.47.26553

85. *Pouch*
Northern Plains: Santee Dakota or Red River
 Metis
Late nineteenth to early twentieth century
Native-tanned hide, rawhide, glass and metal
 beads, sinew
22.5 cm. high (including fringe), 11.7 cm. wide
Overlay beading technique
985.47.26554

86. *Pouch*
Central Plains
Early twentieth century
Fur (hare), native-tanned hide (elk or moose),
 glass beads
23.0 cm. high, 11.0 cm. wide
985.47.26504

87. *Pouch*
Eastern Woodlands: Iroquois
Late nineteenth century
Cloth, glass beads, paper, thread
12.2 cm. high, 13.2 cm. wide
Overlay stitch beading technique
985.47.26659

Beaded pouches, pin cushions, and hanging ornaments
were made in large quantities by Iroquois beadworkers
for sale to tourists at such places as Niagara Falls. Evi-
dent on this example are the paper patterns over which
the beads were sewn. The use of paper patterns for
beadwork was most common in the Northeast.

88. *Tobacco Bag*
Central Plains: probably Lakota or Assiniboin
Late nineteenth century
Native-tanned hide, rawhide, glass beads, sinew
41.0 cm. high (including fringe), 11.7 cm. wide
Lazy stitch beading technique
985.47.26555

Made from two armbands.

*89. *Pipe Bag*
Southern Plains: probably Cheyenne
Late nineteenth century
Native-tanned hide, glass beads, sinew, yellow
 ochre
49.0 cm. high (including fringe), 13.2 cm. wide
Lazy stitch beading technique
985.47.26556

Pipes served an important spiritual function among
many Native Americans. Since they were prized ob-

jects, it was only natural that the cases made to hold them were often highly ornamented. When placed in the bag, the pipe stem and bowl were separated. The small size and delicate feeling of this bag suggest that it may have been for a woman's pipe.

*90. *Pipe Bag*
Southern Plains: Cheyenne or Arapaho
Late nineteenth century
Native-tanned hide (doe), glass beads, sinew
65.0 cm. high (including fringe), 17.0 cm. wide
Lazy stitch beading technique
985.47.26557

This beadwork exhibits the "Morningstar" motif.

91. *Pipe Bag*
Central Plains
Late nineteenth to early twentieth century
Native-tanned hide (antelope or deer), glass beads, sinew
88.0 cm. high (including fringe), 16.5 cm. wide
Lazy stitch beading technique
985.47.26558

92. *Pipe Bag*
Northern Plains: probably Plains Cree or Sarci
Late nineteenth to early twentieth century
Cloth, glass beads, native-tanned hide, thread
70.0 cm. high (including fringe), 17.5 cm. wide
Overlay stitch beading technique
985.47.26559

The beaded section is made from a woman's legging.

*93. *Pipe Bag*
Northern Plains: possibly Blackfoot or Cree
Late nineteenth century
Native-tanned hide (doe), glass beads, porcupine quills, thread, red ochre
99.0 cm. high (including fringe), 15.3 cm. wide
Overlay stitch beading technique
985.47.26560

The checkerboard style of beadwork is common to the Blackfoot, Sarci, Cree, and Assiniboin of the Northern Plains.

94. *Pipe Bag*
Plateau/Northern Plains
Early to mid twentieth century
Native-tanned hide (doe), commercial leather, glass beads, cloth, thread, sinew
60.0 cm. high (including fringe), 16.5 cm. wide
Overlay stitch beading technique
985.47.26561

Probably put together with pieces from different objects and made for sale.

95. *Pipe Bag*
Central Plains
Late nineteenth century
Native-tanned hide (deer), glass and metal beads, thread, sinew
60.0 cm. high (including fringe), 18.0 cm. wide
Lazy stitch beading technique
985.47.26562

The beadwork is actually a woman's legging. The green stripe can be observed to change in width. When the legging was worn, the narrow part of the line would be over the back of the ankle.

96. *Pipe Bag*
Central Plains: Lakota type
1920s–40s
Native-tanned hide (deer, cow), rawhide (calf), glass beads, porcupine quills, horsehair, metal, sinew, thread
74.0 cm. high (including fringe), 18.2 cm. wide
Lazy stitch beading technique
985.47.26563

The red, white, and blue "coup feathers" located just above the main beadwork panel suggest this may have been a victory bag given to a returning soldier after World War II.

97. *Pipe Bag*
Central Plains
Ca. 1920s–30s
Native-tanned hide (cow), rawhide (deer), glass beads, porcupine quills, metal, cones, feathers, sinew
76.0 cm. high (including fringe), 19.0 cm. wide
Lazy stitch beading technique
985.47.26564

*98. *Pipe Bag*
Central Plains: Lakota type
Late nineteenth century
Native-tanned hide (antelope, deer), rawhide (deer), commercial leather, glass beads, porcupine quills, metal, feathers, thread, sinew
105.0 cm. high (including fringe), 16.5 cm. wide
Lazy stitch beading technique
985.47.26565

99. *Pipe Bag*
Central Plains: possibly Lakota
Late nineteenth century
Native-tanned hide (doe), rawhide, glass beads, porcupine quills, cloth, sinew, pigment
98.5 cm. high (including fringe), 13.5 cm. wide
Lazy stitch beading technique
985.47.26566

Attached tag marked "White Elk." White Elk was a Lakota warrior who was active during the 1870s and 1880s.

100. *Pipe Bag*
Plateau
Early twentieth century
Native-tanned hide (elk, bison), glass beads, cloth, thread
83.0 cm. high (including fringe), 18.0 cm. wide
Overlay stitch beading technique
985.47.26567

101. *Pouch*
Central Plains: Oglala Lakota or Cheyenne
Early twentieth century
Commercial leather, glass beads, sinew
46.0 cm. high (including fringe), 22.5 cm. wide
Lazy stitch beading technique
985.47.26568

Attached tag marked "Old Flathead Pipe Bag." A non-traditional shape, this pouch is identified by the beadwork motif and technique as coming from the Central Plains rather than from the Flathead people. It is possible, however, that the pouch was obtained by the Flathead from the Lakota, and later sold to a visiting tourist or trader. An almost identical bag in the Hood Museum collections was obtained prior to 1906 from the Cheyenne in Oklahoma.

102. *Gun Case*
Northern Plains: probably Blackfoot or Assiniboin
Late nineteenth century
Native-tanned hide, glass beads, wool cloth, thread
107.0 cm. high, 16.5 cm. wide
Overlay stitch beading technique
985.47.26569

The making of ornamented gun cases is a carryover from the traditional practice of decorating quivers or lance covers. The gun, like other weapons and pipes, was an item of prestige and warranted special treatment. Firearms owned by Native Americans were often decorated with brass tacks. Most gun cases of this shape and size were made to fit the Winchester repeating rifle.

103. *Gun Case*
Northern Plains: probably Southern Blackfoot or Assiniboin
1920s–40s
Native-tanned hide, glass beads, canvas, sinew
112.5 cm. high, 16.0 cm. wide (excluding fringe)
Overlay stitch beading technique
985.47.26570

*104. *Gun Case*
Subarctic: Western Athapaskan, Kutchin
Early to mid twentieth century
Native-tanned hide (caribou), cloth, glass beads, dentalium shells, thread
124.5 cm. high, 20.7 cm. wide
Overlay stitch beading technique
985.47.26571

105. *Gun Case*
Subarctic: Athapaskan, Yukon-Tanana region
Early twentieth century
Native-tanned leather (moose), cloth, glass beads, sinew, thread
119.0 cm. high, 15.8 cm. wide
985.47.26572

*106. *Shoulder Bag*
Great Lakes: probably Chippewa (Ojibwa)
Late nineteenth century
Native-tanned leather, commercial leather, glass
 beads, cloth, thread
76.0 cm. high, 13.0 cm. wide
Overlay stitch beading technique
985.47.26573

An example of one of the many types of beaded pouches used in the Great Lakes and Eastern Woodlands areas.

107 *Bandolier*
Great Lakes: Menominee type
Late nineteenth to early twentieth century
Cloth, glass beads, wool yarn, commercial thread
100.0 cm. high, 36.5 cm. wide
Woven beading technique
985.47.26574

These bags probably originated from functional shoulder bags, many variations of which were in use among Eastern Woodland peoples during the last three hundred years. By the mid nineteenth century, these developed into ornate accessories to formal male clothing. Worn at dances or other ceremonial occasions, they served as an item of prestige, and men often wore two or more at the same time, one slung over each shoulder. Some bandolier bags, such as this example, were merely decorative beaded panels and lacked even a rudimentary pouch.

*108. *Bandolier Bag*
Great Lakes: Chippewa (Ojibwa) type
Late nineteenth century
Cloth, glass and metal beads, wool yarn, thread
109.5 cm. high, 38.5 cm. wide
Overlay stitch beading technique
985.47.26575

An example of the dramatic floral beaded bags produced around the turn of the century.

*109. *Bandolier Bag*
Great Lakes: Menominee type
Late nineteenth to early twentieth century
Cloth, glass beads, wool yarn, thread
102.0 cm. high, 44.0 cm. wide
Woven beading technique
985.47.26576

Collected by the donor's father prior to 1905, possibly from Indians who used to gather wild rice near the Rahr family camp in northern Michigan, this bag was probably the first object in the Rahr collection. Woven

beadwork was especially favored among Indians of the Great Lakes who produced large quantities of sashes, garters, and bandolier bags using this method. Actually there are several variations of this technique, some of which are not done on a loom as is usually thought.

*110. *Bandolier Bag*
Great Lakes: probably Chippewa (Ojibwa) or
 Potawatomi
Mid to late nineteenth century
Cloth, glass beads, wool yarn, thread
97.0 cm. high, 34.0 cm. wide
Woven, and overlay stitch beading techniques
985.47.26577

Though woven bandolier bags were made until the turn of the century, they usually date prior to 1885, which is probably the case with this example. Other traits that generally indicate older bags are the geometric motif and the tabs and pompoms at the top of the bandolier. On this piece, the design of the bandolier follows closely that on the pouch itself, a trait found more commonly on Potawatomi bags (Andrew Hunter Whiteford, pers. com. 1986).

*111. *Bandolier Bag*
Great Lakes: possibly Canadian Ojibwa
Late nineteenth to early twentieth century
Cloth, glass beads, thread
109.0 cm. high, 24.5 cm. wide
Overlay stitch beading technique
985.47.26578

112. *Ceremonial Belt*
Great Lakes: Chippewa (Ojibwa) type
Late nineteenth to early twentieth century
Cloth, glass beads, thread
108.5 cm. high, 11.5 cm. wide
Overlay stitch beading technique
985.47.26579

The mixed color background probably developed from the beadworker's purchasing less costly bags of unsorted beads or utilizing her own assorted stock left over from previous projects. Some Native Americans refer to this as "hit or miss," meaning that one plunged the needle into a bag of assorted beads and used whatever came out (Thorburn, 1986).

113. *Ceremonial Belt*
Great Lakes: Chippewa (Ojibwa) type
Late nineteenth to early twentieth century
Cloth, glass beads, thread
79.0 cm. high, 12.3 cm. wide
Overlay stitch beading technique
985.47.26580

*114. *Belt*
Northern Plains/Intermontane
Ca. 1880–85
Commercial leather, glass beads, brass studs, iron
 buckle, thread
97.5 cm. high, 5.1 cm. wide
Lazy stitch beading technique
985.47.26581

These belts were traditionally used by women, but by
the 1890s they were worn by both sexes on dress occa-
sions. Earlier versions of the belts had rectangular sec-
tions devoid of beadwork. Later, these areas were orna-
mented with brass tacks. Catalogue number 116 is prob-
ably a later example and lacks the non-beaded sections
(Conn 1986).

*115. *Belt*
Northern Plains: probably Flathead
Late nineteenth century
Commercial leather, glass beads, sinew
92.5 cm. high, 3.7 cm. wide
Lazy stitch beading technique
985.47.26582

Exhibits the "fish" beadwork motif commonly used by
the Flathead.

*116. *Belt*
Northern Plains
Late nineteenth century
Commercial leather, glass and metal beads, thread
76.5 cm. high, 5.1 cm. wide
Overlay and lazy stitch beading techniques
985.47.26583

This belt is partly done in the northern checkerboard
style of beading common to the Blackfoot, Cree, Assin-
iboin, and Sarci.

117. *Belt*
Northern Plains
Late nineteenth century
Commercial leather, glass beads, thread
81.7 cm. high, 6.5 cm. wide
Overlay and lazy stitch beading techniques
985.47.26584

118. *Clothing Strip*
Northern Plains: probably Blackfoot or Assini-
 boin
Early twentieth century
Cloth, glass beads, thread
95.0 cm. high, 6.0 cm. wide
Overlay stitch beading technique
985.47.26585

Beaded strips like these were made in pairs and in-
tended to be attached to articles of clothing, usually a
man's shirt (see Cat. 134) or leggings. When the cloth-
ing wore out the beadwork would be reused.

119. *Pair of Clothing Strips*
Northern Plains: possibly Blackfoot or Flathead
Late nineteenth to early twentieth century
Native-tanned hide (elk), glass beads, thread
84.0 cm. high, 6.5 cm. wide
Overlay stitch beading technique
985.47.26586a,b

120. *Pair of Clothing Strips*
Central Plains: probably Lakota
Late nineteenth to early twentieth century
Native-tanned hide, glass beads, sinew
74.8 cm. high, 6.1 cm. wide
Lazy stitch beading technique
985.47.26587a,b

121. *Pair of Garters*
Great Lakes
Late nineteenth to early twentieth century
Glass beads, wool yarn, thread
76.0 cm. high (including fringe), 7.6 cm. wide
Woven beading technique
985.47.26588a,b

122. *Garter*
Great Lakes
Late nineteenth to early twentieth century
Glass beads, wool yarn, thread
61.0 cm. high (including fringe), 6.0 cm. wide
Woven beading technique
985.47.26589

Beaded garters were worn at dances and other special
occasions.

123. *Sash*
Great Lakes
Late nineteenth to early twentieth century
Glass and metal beads, wool yarn, thread
127.0 cm. high (including fringe), 5.1 cm. wide
Woven beading technique
985.47.26590

124. *Sash(?)*
Great Lakes
Late nineteenth to early twentieth century
Glass and metal beads, thread
78.2 cm. high, 4.5 cm. wide
Woven beading technique
985.47.26591

125. *Sash(?)*
Great Lakes
Late nineteenth to early twentieth century
Glass beads, thread
180.0 cm. high (including fringe), 3.5 cm. wide
Woven beading technique
985.47.26592

*126. *Boy's Vest*
Central Plains: Lakota
Ca. 1885–95
Native-tanned hide (deer), glass and metal beads,
 ribbon, thread, sinew, yellow ochre
39.0 cm. high
Lazy stitch beading technique
985.47.26593

The use of faceted metal beads was most popular from
1885 to 1895. The linear beadwork motif along the
lower part of the vest is thought to represent meat-
drying racks.

127. *Boy's Vest*
Central Plains: Lakota
Late nineteenth to early twentieth century
Native-tanned hide (deer), glass beads, sinew
21.8 cm. high
Lazy stitch beading technique
985.47.26594

The linear beadwork motif at the bottom of the vest
may represent meat-drying racks. The U-shaped de-
signs represent horse tracks.

*128. *Man's Vest*
Northern Plains/Intermontane
Early twentieth century
Commercial leather, glass beads, cloth, thread
57.0 cm. high
Overlay stitch beading technique
985.47.26595

From about 1885 to 1915, it was popular among many
Plains groups to cover articles of clothing, particularly
vests, completely with glass trade beads. Such attire
was made not only to be worn on special occasions,
but also to demonstrate the skill of the beadworker.
The vest, a nontraditional garment, was adopted from
European clothing. The floral motif, also showing
Europen influence, was used by many American Indian
groups. The static placement of the flowers and use of
unnatural colors in this example is characteristic of
Crow and Plateau area work. Also incorporated in the
design are the initials "A.L.," probably those of the
original owner. The use of nontraditional materials and
design elements in this vest demonstrates how Native
Americans assimilated foreign materials and tastes to
create their own distinctive art forms.

*129. *Man's Vest*
Northern Plains: possibly Plains Cree
Early twentieth century
Native-tanned hide (deer), cloth, glass and metal
 beads, thread
45.5 cm. high
Overlay stitch beading technique
985.47.26596

130. *Dress Yoke*
Great Lakes: probably Chippewa (Ojibwa)
Early twentieth century
Cloth, glass beads, thread
65.0 cm. high, 60.0 cm. wide
Overlay stitch beading technique
985.47.26597

*131. *Boy's Vest*
Central or Eastern Plains: Lakota or Dakota
Ca. 1900
Native-tanned hide (doe), porcupine quills, thread
32.2 cm. high
985.47.26598

Before the introduction of glass beads, dyed porcupine
quills were extensively used for ornamentation. When
used, quills were first softened in water, then pulled be-
tween the teeth to flatten them. Though diminishing in
popularity after beads became available, the use of
quills for ornamentation continues today. While floral
quillwork is associated more with Dakota, the mass and
stiffness of the figures on this vest suggests Lakota work.

132. *Dance Cape(?)*
Northern Plains: probably Blackfoot or Plains
 Cree
Early twentieth century
Cloth, glass beads, native-tanned hide, thread
59.5 cm. high (including fringe)
Overlay stitch beading technique
985.47.26599

Meant to be worn over a shirt during dances. A similar
example is illustrated in Coe 1976, 174.

*133. *Woman's Blouse*
Great Lakes: possibly Potawatomi
Ca. 1920s–30s
Cloth, glass beads, thread
47.0 cm. high
Overlay stitch beading technique
985.47.26600

This shirt with stylized floral motifs exhibits the bead-
ing technique most commonly associated with the
Potawatomi. This style is characterized by a double,
beaded border around the individual elements of the
motif, with the beads that are used to fill each element
running perpendicular to the border. Contrast this with
Chippewa work where bead rows follow the contours
of the design elements (see bandolier bag, Cat. 108).

*134. *Man's Warshirt*
Northern Plains: Crow
Ca. 1875
Native-tanned hide (deer), glass beads, long-
 tailed-weasel fur, cloth, thread
70.0 cm. high
Overlay stitch beading technique
985.47.26601

Associated with leggings, Catalogue number 135.
Dealer's tag indicates that it belonged to "Chief Pretty
Eagle." In the biography of Plenty Coups by Frank
Linderman, Pretty Eagle is mentioned as a Crow war-
rior alive during the second half of the nineteenth cen-
tury. The shirt is made of two skins matched in size
and shape and sewn together. Originally the wearing of
such shirts was reserved for tribal leaders as a symbol
of honor and rank. Later, respected members of war-
rior societies also wore such garments, often painted
with symbols alluding to the owner's war exploits.
Even when battle honors were no longer attainable, the
shirts still signified that the owner was a man of impor-
tance among his people (Hail 1980). The weasel was re-
spected for its fierce nature and was considered good
war medicine. White weasel pelts, called "ermine," were
collected during winter when the animal's fur had
turned completely white except for the black tip at the
end of the tail. Weasel fur was also used to decorate
other clothing such as leggings and headdresses (see
headdress, Cat. 182).

135. *Pair of Leggings*
Northern Plains
Late nineteenth century
Wool cloth, glass beads, thread
85.0 cm. high
Overlay stitch beading technique
985.47.266062a,b

Associated with shirt, Catalogue number 134.

*136. *Girl's Dress*
Central Plains: Northern Cheyenne, Lame Deer,
 Montana
Made by Mrs. Victor Little Chief (1875–1937)
Ca. 1920s–30s
Native-tanned hide (elk, deer), glass beads, bone,
 sophora beans, sinew, thread
70.0 cm. high
Lazy stitch beading technique
985.47.26603

Attached tag marked: "Made by Mrs. Victor Little
Chief." Mrs. Little Chief lived at Lame Deer, Montana.
Though she was childless, she did have nieces and may
well have made this dress for one of them. Though of
late manufacture, the beadwork motifs are typical and
traditional for the Cheyenne. The red sophora beans
are a hallucinogenic drug, and were associated with a
religious movement known as the "bean cult." Because
of this association, the beans are considered a power
symbol. Also adorning the dress are pieces of bone
carved in the shape of an elk's upper canine teeth. An
elk only has two such teeth, and originally a dress dec-
orated with so many teeth would be a prestigious ob-
ject indeed, indicating that the woman's husband or
father was a great hunter. Later, bone copies of the
teeth were used and their significance became less pres-
tigious and more ornamental. The hide used in this
garment was finely tanned in the traditional manner, a
time-consuming process. Tanning was done by women,
who were justly as proud of their work as men were of
their skill in hunting. To begin, the underside of the
hide was scraped clean of tissue and fat. Staked out in
the sun to dry for a few days, the hide was then
scraped again until it was of uniform thickness. At this
point, the hair was removed from the other side. One
now had a sheet of rawhide, suitable for making par-
fleches, moccasin soles, or boxes such as Catalogue
numbers 59, 60, and 61. If the woman wanted a tanned
hide she continued the process. The skin was rubbed
with a mixture of brains, fat, and liver, then left to dry
for a while. The next step involved stretching the hide
manually, rubbing it with stones, and pulling it back
and forth across a pole or length of twisted rawhide.
This procedure softened the leather, making it ready
for use. Often, especially if the hide was to be used in
clothing, it was further treated by subjecting it to
smoke from a smouldering fire. Smoking helped to pre-
vent the hide from becoming stiff after getting wet,
and the faint smoky odor that remained in the skin was
also said to repel mosquitos (Ewers 1945, 10–13).

137. *Boy's Coat*
Central Plains: possibly Dakota
Early twentieth century
Native-tanned hide (fawn), porcupine quills,
 cloth, sinew, thread, aniline dye
50.0 cm. high
985.47.26604

The coat is not a traditional style but modeled after a
European garment.

138. *Blanket Strip*
Central Plains: probably Lakota
Late nineteenth century
Native-tanned hide (cow), glass beads, cloth,
 sinew
12.0 cm. high, 142.5 cm. wide
Lazy stitch beading technique
985.47.26605

Strips of bead or quillwork were originally developed
to conceal the center seam of a bison skin robe, the re-
sult of the hide having been cut in half during the tan-
ning process. Later, when trade blankets came into use,
the beaded strips were still retained as decorative ele-
ments. When the blanket or robe was worn, the strip
appeared horizontally across the wearer's back. This ex-
ample is unusual in that it contains two small bundles
of "medicine," special material that acts as a charm to
help assure the well-being of the owner. Similar "medi-
cine" bundles appear on the baby carrier, Catalogue
number 68.

*139. *Woman's Necklace*
Central Plains: Lakota type
Late nineteenth to early twentieth century
Cow bone, commercial leather, string, glass
 beads, cowrie shells
62.2 cm. high, 23.0 cm. wide
985.47.26606

These large, heavy necklaces were especially popular
among the Sioux from 1900 to 1920. The long tubular
beads are called "hair pipes," because originally they
were used singly as hair ornaments. Laboriously made
from stone, shell, or bone, they were considered of
great value by the Indians. By the seventeenth centu-
ry, hair pipes of bone, glass, and shell were commercial-
ly manufactured for trade with Native Americans.
Copied from the traditional tubular beads, they became
cheaper for the Indians to purchase and were used to
form objects such as breastplates and women's com-
plex necklaces. Hair pipes are still widely used for
dress costumes, and are now also available in plastic
(Hail 1980).

140. *Man's Breastplate*
Plains
Late nineteenth to early twentieth century
Cow bone, commercial leather, brass beads,
 cowrie shells
48.0 cm. high, 21.0 cm. wide
985.47.26607

Attached tag: "Flathead Indian." Breastplates such as
this were worn by many Plains groups. As with the
woman's necklace, Catalogue number 139, the bone
beads were commercially made in the East.

141. *Man's Necklace*
Northern Plains: Crow type
Early twentieth century
Bone, commercial leather, glass and metal beads,
 cowrie shells, thread
62.2 cm. high, 23.0 cm. wide
985.47.26608

142. *Necklace*
Plains
Late nineteenth to early twentieth century
Bovine teeth, wooden beads, string
93.5 cm. long
985.47.26609

143. *Belt(?)*
Native American(?)
Late nineteenth century(?)
Commercial Leather, animal teeth (dog[?]),
 thread
87.5 cm. long
985.47.26610

144. *Horse's Head Stall*
Plains
Late nineteenth to early twentieth century
Native-tanned hide, glass beads, metal cones,
 porcupine quills, feathers, sinew
43.5 cm. long, 6.2 cm. wide
985.47.26612

145. *Hair Ornament*
Plains
Late nineteenth to early twentieth century
Cloth, glass beads, horsehair, metal cones,
 feathers, porcupine quills, thread
63.0 cm. high, 6.8 cm. wide
985.47.26613

A later version of the man's quilled hair ornament
known as a "Buffalo Bull's Tail" (Hail 1980, 124).

146. *Tipi Ornaments(?)*
Plains
Early twentieth century
Commercial leather, porcupine quills, metal, horsehair
Each ca. 15.0 cm. high, 2.1 cm. wide
985.47.26614a–z

147. *Pair of Gauntlets*
Canada: Northern Plains/Plateau
Early to mid twentieth century
Native-tanned hide (moose), glass and metal beads, cloth, thread
46.0 cm. high, 18.0 cm. wide
Overlay stitch beading technique
985.47.26615a,b

148. *Pair of Leggings*
Central Plains: possibly Arapaho
Late nineteenth to early twentieth century
Native-tanned hide (antelope), glass beads, metal cones, sinew
Ca. 38.0 cm. high, 32.5 cm. wide
Lazy stitch beading technique
985.47.26616a,b

149. *Woman's Leggings*
Northern Plains
Early twentieth century
Cloth, glass beads, thread
Overlay stitch beading technique
985.47.26617a,b,

150. *Leggings*
Northern Plains: possibly Blackfoot
Late nineteenth to early twentieth century
Cloth, glass beads, tanned hide, thread
25.0 cm. high
Overlay stitch beading technique
985.47.26618a,b

The beadwork on this pair is unfinished, though the design stops at the same place for each piece. This suggests that the maker worked on each cuff simultaneously, rather than finishing one and then making a duplicate. Perhaps with this pair, an opportunity to sell them at a good price came up before the pieces were completed.

151. *Cuffs*
Central Plains: Lakota
Ca. 1930s
Native-tanned hide (elk), cloth, glass beads, sinew, thread
15.5 cm. high
Lazy stitch beading technique
985.47.26619a,b

The unevenness of the work suggests that it was manufactured by an inexperienced beadworker.

152. *Cuffs*
Central Plains: Lakota
Native-tanned hide (deer), glass beads, cloth, thread
13.7 cm. high
Lazy stitch beading technique
985.47.26620a,b

153. *Cuffs*
Northern Plains: possibly Flathead
Late nineteenth to early twentieth century
Native-tanned hide (cow), glass beads, cloth, thread
14.7 cm. high
Overlay beading technique
985.47.26621a,b

Attached tag "Flathead, Montana, 75 years old."

154. *Armbands*
Central Plains: Lakota
Late nineteenth century
Native-tanned hide, glass and metal beads, sinew
16.0 x 8.0 cm.
Lazy stitch beading technique
985.47.26622a,b

*155. *Moccasins*
Northern Plains: probably Crow
Late nineteenth to early twentieth century
Native-tanned hide (deer), glass beads, sinew, thread
25.0 cm. long
Overlay and lazy stitch beading techniques
985.47.26623a,b

156. *Moccasins*
Oklahoma: Cheyenne type
Ca. 1930s–40s
Rawhide (calf), native-tanned hide (antelope),
 glass beads
39.0 cm. long
Lazy stitch beading techniques
985.47.26624a,b

157. *Man's Moccasin*
Central Plains: probably Lakota
Late nineteenth to early twentieth century
Rawhide, native-tanned hide (doe), glass beads,
 sinew
26.5 cm. long
Lazy stitch beading technique
985.47.26625

The sole is made of a piece cut from an old parfleche,
and is marked "Apache, Bad Lands, So. Dakota." While
this attribution sounds unlikely, as the Apache are from
the Southwest, such information should never be dis-
missed out of hand. During the early part of this cen-
tury some Indians, such as those acting in Wild West
shows or films, travelled to other parts of the country
and could easily have sold things while far from home.
Also, objects were commonly traded among Native
Americans and something collected from a Cheyenne
may well have been made by a member of a far distant
group.

158. *Men's Moccasins*
Central Plains: Cheyenne type
Ca. 1930s–40s
Rawhide (deer), native-tanned hide (deer), glass
 beads, sinew
26.0 cm. long
Lazy stitch beading technique
985.47.26626a,b

Cheyenne moccasins have several distinguishing charac-
teristics; the inner side of the sole is cut in a straight
line, the ankle flaps are cut so that they slant from back
to front, and the beaded decoration around the border
of the moccasin consists of an odd number of major
figures, one of which is positioned over the toe. A
forked tongue is thought to indicate men's moccasins.
The beadwork motif on the instep of this pair repre-
sents the thunderbird (Hail 1980, 106, 107).

159. *Moccasins*
Central Plains
Early twentieth century
Rawhide (antelope, bison), native-tanned hide
 (bison), glass beads, cloth, sinew
25.2 cm. long
Lazy stitch beading technique
985.47.26627a,b,

The sole is cut from an old parfleche, a common source
for rawhide moccasin soles.

160. *Moccasins*
Central Plains: Cheyenne
Late nineteenth century
Rawhide (deer), native-tanned hide (deer), glass
 beads, sinew
26.5 cm. long
Lazy stitch beading technique
985.47.26628a,b

This pair exhibits the "Buffalo track" beadwork motif
on either side of the vamp (see Hail 1980, 106, 107).

161. *Moccasins*
Northern Plains: Blackfoot
Early twentieth century
Rawhide (calf), native-tanned hide (elk), cloth,
 glass beads, sinew
22.5 cm. long
Overlay stitch beading technique
985.47.26629a,b

The beadwork motif known as "three finger block," is
based on an old quillwork design. Some writers have
suggested that the three lines represent the three divi-
sions of the Blackfoot, but native informants deny this
(Ewers 1945, 41).

162. *Moccasins*
Northern Plains: Blackfoot
Early twentieth century
Rawhide (calf), native-tanned hide (deer), glass
 beads
27.5 cm. long
Overlay stitch beading technique
985.47.26630a,b

163. *Moccasins*
Central Plains: possibly Arapaho or Lakota
Late nineteenth century
Rawhide (deer), native-tanned hide (deer), glass
 beads, porcupine quills, cloth, sinew, thread
28.3 cm. long
Lazy stitch beading technique
985.47.26631a,b

164. *Moccasins*
Canada, Northern Plains: probably Lakota or
 Assiniboin
Ca. 1920s
Rawhide, native-tanned hide (cow), glass beads,
 porcupine quills, sinew, thread
28.3 cm. long
Lazy stitch beading technique
985.47.26632a,b

Probably made for sale.

165. *Child's Moccasins*
Central Plains: Cheyenne type
Ca. 1930s–40s
Rawhide (deer), native-tanned hide (deer), glass
 beads, sinew
14.3 cm. long
Lazy stitch beading technique
985.47.26633a,b

166. *Woman's Moccasins*
Central Plains: Lakota type
Early twentieth century
Rawhide (deer), native-tanned hide (deer), glass
 beads, cloth, sinew
24.7 cm. long
Lazy stitch beading technique
985.47.26634a,b

A tongue cut in an oval shape is usually indicative of
women's moccasins.

167. *Moccasins*
Central Plains: Lakota type
Early twentieth century
Rawhide, native-tanned hide (deer), glass and
 metal beads, sinew
24.0 cm. long
Lazy stitch beading technique
985.47.26635a,b

The sole is cut from an old parfleche.

168. *Moccasins*
Central Plains
Early twentieth century
Rawhide (calf), native-tanned hide (cow), glass
 beads, sinew
23.5 cm. long
Lazy stitch beading technique
985.47.26636a,b

169. *Moccasins*
Northern Plains: probably Northern Lakota or
 Assiniboin
Ca. 1920s
Native-tanned hide (deer), glass beads, cloth,
 thread
25.5 cm. long
Lazy stitch beading technique
985.47.26637a,b

170. *Moccasins*
Northern Plains: probably Northern Lakota or
 Assiniboin
Late nineteenth to early twentieth century
Native-tanned hide (bison, deer), glass and metal
 beads, porcupine quills, velvet, thread
26.0 cm. long
Lazy stitch beading technique
985.47.26638a,b

171. *Moccasins*
Northern Plains: Blackfoot type
Early twentieth century
22.0 cm. long
Rawhide (deer), native-tanned hide (bison or
 cow), cloth, glass beads, thread
Overlay stitch beading technique
985.47.26639a,b

Type of beadwork motif called "white man's sewing"
(Ewers 1945, 40,41).

*172. *Woman's Moccasins*
Northern Woodlands
Nineteenth century
Native-tanned hide, fur, cloth, glass beads
Overlay stitch beading technique
985.47.26640a,b

The dealer's tag calls these the wedding moccasins
worn by the bride of Chief Oshkosh. Oshkosh was a
Menominee chief from Wisconsin. He was married
three times and died in 1858 (Hoffman 1896). If the
documentation is correct, these moccasins probably be-
longed to his third wife. The soft, one-piece moccasin
with pointed toes is a style favored in the subarctic and
northern woodlands. The beadwork traits of color-

divided floral motifs, double outlining of the elements, and open spaces within the elements, are similar to beading styles practiced among the Tlingit during the 1880s and 1890s (Kate Duncan, pers. com. 1986). These traits, however, may have been practiced earlier among tribes further east.

173. *Moccasins*
Northern Plains: Cree type
Late nineteenth to early twentieth century
Native-tanned hide (bison), glass beads, sinew
27.0 cm. long
Overlay and lazy stitch beading techniques
985.47.26641a,b

Several horizontal rows of beads acting as a border around the edge of the instep are a typically Cree trait.

174. *Doll*
Central Plains: Lakota
Early twentieth century
Native-tanned hide (deer), glass beads, cloth, porcupine quills, human hair, thread
37.0 cm. high, 13.5 cm. wide
985.47.26642

Given to little girls, dolls served not only as toys but as props in role playing.

175. *Model Baby Carrier with Doll*
Plateau: probably Nez Perce
Ca. 1930s–40s
Native-tanned hide (doe), glass beads, cloth, thread
28.0 cm. high, 15.5 cm. wide
Woven and overlay stitch beading techniques
985.47.26643

A variation of the U-shaped baby carrier style predominant in the Plateau and Northern Plains, the Nez Perce type lacked the beaded bands found on Crow examples. Dolls and model baby carriers were made to be given to little girls, as well as for sale to tourists.

176. *Dance Roach*
Plains
Early to mid twentieth century
Porcupine hair, cord, golden eagle feathers
34.5 cm. long (excluding feather), 6.1 cm. wide
985.47.26644

A headdress variation used for dancing, the roach was usually made from porcupine hair, deer hair, or horsehair. When worn it resembled a trimmed horse's mane or a porcupine, whose mantel of quills probably first inspired the style. This style originated among tribes of the Eastern Woodlands, where some Indians originally cut their hair in this way. Today called a "Mohawk"

haircut, it was actually used by many other groups. The use of roach-type headdresses had reached the Plains by the latter half of the nineteenth century, and among the Omaha, became a ritual accoutrement both for indicating war honors achieved by the wearer, and for use in the Grass Dance. Their use gradually spread to other Plains tribes and today this headgear is a common sight at pow-wows around the country. To increase the dramatic effect, a flat, rounded piece of bone or rawhide, called a spreader, is placed in the center of the roach, causing the hair to flare outward at a slight angle. Many roaches now are dyed vibrant colors, with a few dangling feathers also added for further ornamentation.

177. *Dance Roach*
Plains
Early to mid twentieth century
Cloth, porcupine hair
32.0 cm. long, 6.0 cm. wide
985.47.26645

Attached tag: "Sioux, Porcupine head roach, 'Big Turnip.'"

178. *Dance Roach*
Plains
Early to mid twentieth century
Porcupine hair, commercial leather, glass beads, feathers, cloth, yarn, thread
32.0 cm. long, 8.6 cm. wide
Overlay stitch beading technique
985.47.26646

179. *Headdress*
Northern Plains
Late nineteenth to early twentieth century
Felt, commercial leather, native-tanned hide, bison horn, weasel, fur, wool cloth, glass beads, porcupine quills, feathers, sinew, thread
74.0 cm. high
Lazy stitch beading technique
985.47.26647

180. *Headdress*
Native American
Ca. 1951–56
Cloth, feathers, glass beads, weasel fur, horsehair
Ca. 44.0 cm. high
Woven beading technique
985.47.26648

Given by Native Americans from Wisconsin to Walter J. Kohler, Jr., during his tenure as Governor of Wisconsin 1951–56. Given by Governor Kohler to Mr. Rahr, a friend and former college roommate.

181. *Headdress*
Native American
Ca. 1951–56
Commercial leather, feathers, cloth, glass beads,
 thread
Ca. 44.0 cm. high
Woven beading technique
985.47.26649

Given by Native Americans from Wisconsin to Walter
J. Kohler, Jr., during his tenure as Governor of Wis-
consin 1951–56.

182. *Headdress*
Plains: Lakota type
Early twentieth century
Native-tanned hide, golden eagle feathers, wool
 cloth, long-tailed weasel fur, glass beads, yarn,
 thread
164.0 cm. high
Overlay stitch beading technique
986.47.26658

The stereotype of the American Indian ceremonial cos-
tume would not be complete without its most spectac-
ular accoutrement: the feathered "warbonnet." Indeed,
the feather headdress has become the popular symbol
of "Indianness" itself. The historical reality, however, is
far different. Prior to the twentieth century, the geo-
graphical distribution and use of feather bonnets was
relatively restricted. Feathered headdresses evolved from
the ancient custom, common to many Native American
groups, of wearing a single feather attached to the hair
for each act of bravery. By the mid eighteenth century,
the Mandan had begun to place the single feathers in-
to headbands, thus forming crowns of erect feathers.
Other Plains groups subsequently adopted the method,
and throughout the nineteenth century this manner of
display was elaborated to become the striking style of
backward-sweeping and trailing feathers. By 1890, with
war honors no longer attainable in the reservation set-
ting, the specific uses of the warbonnet began to break
down. Feather headdresses were soon thereafter adop-
ted by many non-Plains groups for official and public
appearances as a mark of their Native American iden-
tity. They were further popularized by performers in
"Wild West" shows during the late nineteenth and early
twentieth centuries. Ultimately these headdresses came
to assume a pan-tribal significance as ceremonial attire
and have seen an imaginative revival through profes-
sional performers of the pow-wow circuit. From the
late eighteenth through late nineteenth century, the
Plains warbonnet symbolized both prowess in battle
and the supernatural sanction of a spirit protector. It
was an article of high prestige worn only by experi-
enced warriors and officers of military societies. The
right to wear a warbonnet was earned by "counting
coups," deeds of bravery in combat that aimed to
wound and disable—not kill—the enemy. Each feather
represented such a coup. From its inception as a head-

band with feathers, the bonnet evolved in style and ma-
terial throughout the nineteenth century. The simple
row of trailing feathers was common among Northern
Plains groups in the early nineteenth century. By about
1850 the flaring style of feathered bonnet with two trail-
ing rows of feathers had developed. As trade goods be-
came available, the use of felt hats as a base for the cap
supplanted the leather cap previously used. By 1900,
however, a revival of interest in using traditional meth-
ods led to leather caps being used again as in this ex-
ample. Full length headdresses such as this were meant
to be worn while on horseback.

REFERENCES

Coe, Ralph T. *Sacred Circles: Two Thousand Years of
 North American Indian Art.* London: Arts Council of
 Great Britain, 1976, p. 174.
Conn, Richard. *Native American Art in the Denver Art
 Museum.* Denver Art Museum, 1979, p. 152.
———. *Circles of the World: Traditional Art of the Plains
 Indian.* Denver: Denver Art Museum, 1982.
———. *A Persistent Vision: Art of the Reservation Days.*
 Denver: Denver Art Museum, 1986, p. 159.
Ewers, John C. *Blackfeet Crafts.* Washington, D.C.:
 United States Department of the Interior, Bureau of
 Indian Affairs, 1945, pp. 10–13, 40,41.
Flint Institute of Arts. *Art of the Great Lakes Indians.*
 Flint, Michigan, 1975.
Gogol, J. M. "Cornhusk Bags and Hats of the Colum-
 bia Plateau Indians." *American Indian Basketry* (1980):
 4–10.
———. "Columbia River/Plateau Indian Beadwork."
 American Basketry and Other Native Arts 5, no. 2
 (1985): 3–32.
Hail, Barbara. *Hau, Kola.* Providence, R.I.: The Haf-
 fenreffer Museum of Anthropology, Brown Univer-
 sity, 1980, pp. 106–8, 124, 157.
Harrison, Julia. "'He Heard Something Laugh': Otter
 Imagery in the Midewiwin." *Bulletin of the Detroit
 Institute of Arts* 62, no. 1, (1986): 46–53.
Hoffman, Walter James. "The Menomini Indians." 14th
 Annual Report, pt. 1, Institution, Bureau of Ameri-
 can Ethnology, Washington, D.C., 1896.
Lessard, F. Dennis. "Crow Indian Art: The Nez Perce
 Connection." *American Indian Art* 6, no. 1 (Winter
 1980): 54–63.
Morrow, Mable. *Indian Rawhide.* Norman, Okla.: Uni-
 versity of Oklahoma Press, 1975, p. 224.
Peterson, Harold L. *American Indian Tomahawks.* New
 York: Museum of the American Indian, Heye Foun-
 dation, 1971.
Schlick, Mary D. "Art Treasures of the Columbia Pla-
 teau Indians." *American Indian Basketry Magazine* 1,
 no. 2, (1980): 12–21.
Thornburn, Francis and Abigail. Collection Notes,
 South Dakota Memorial Art Center, Brookings,
 S.D., 1986.
Whiteford, Andrew H. "The Origins of Great Lakes
 Beaded Bandolier Bags." *American Indian Art* 2, no. 3
 (Summer 1986): 32–43.